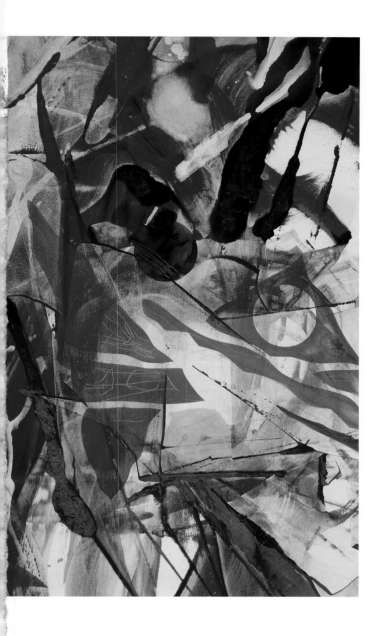

Northwest Perspective Series
Tacoma Art Museum

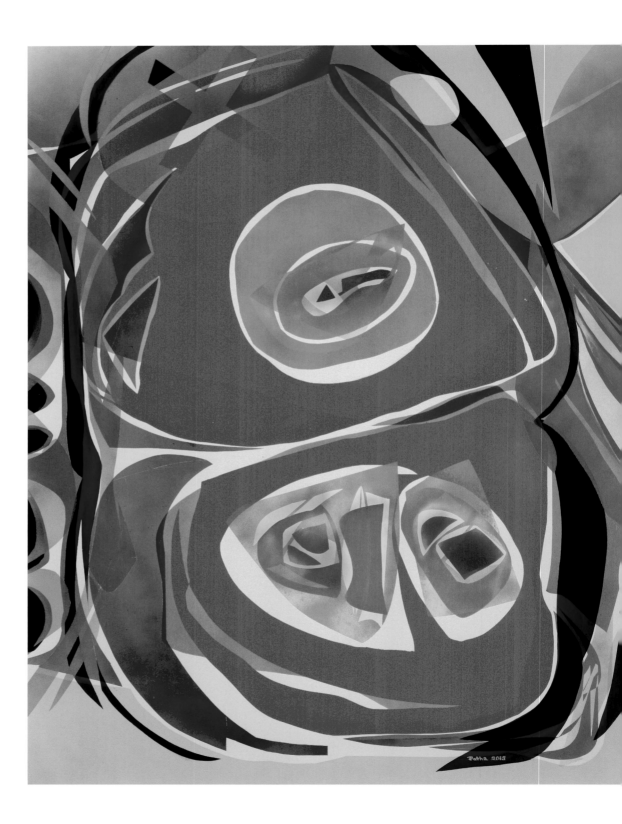

# A PUNCH OF COLOR

Fifty Years of Painting by Camille Patha

Essays by Rock Hushka and Alison Maurer

Tacoma Art Museum
Tacoma, Washington

In memory of Mary Shirley

I am grateful for the support and encouragement of
Jon and Mary Shirley, and I have valued my acquaintance
with Mary, whose extraordinary artistic vision and energy
will always be a lifetime benchmark for women in all fields
and ventures.

—Camille Patha

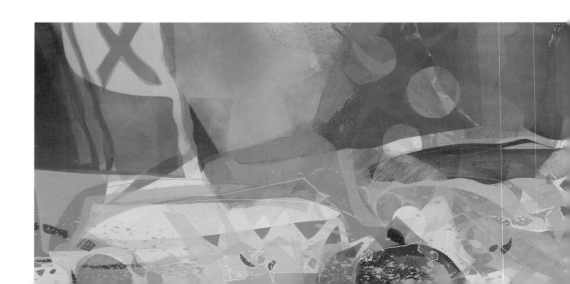

# CONTENTS

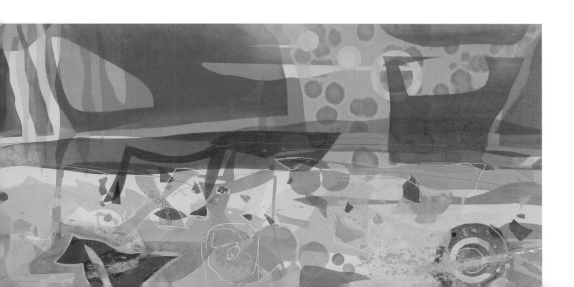

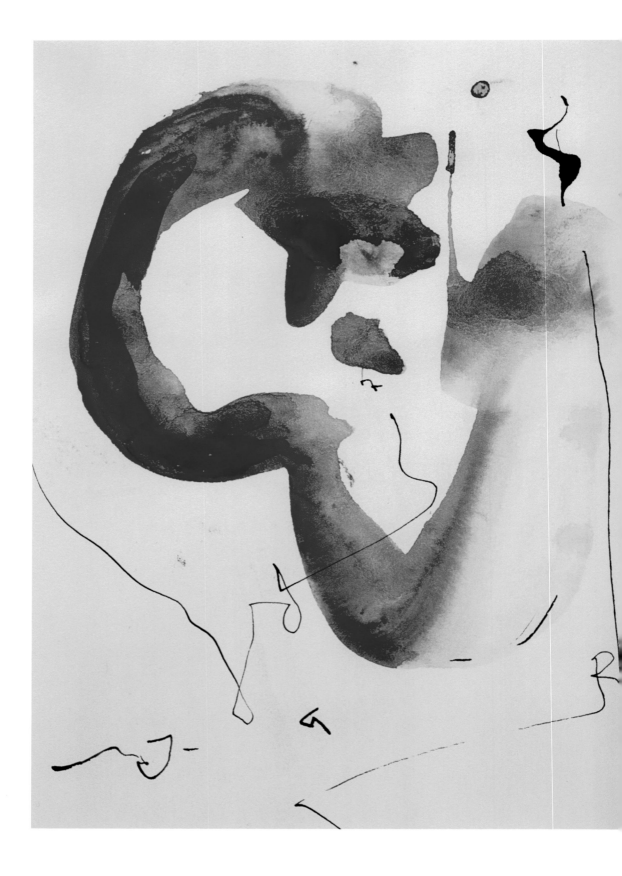

## Director's Foreword

**Stephanie A. Stebich**
*Director*

amille Patha is an artist as bold and colorful as her canvases. She demands attention for the seriousness of her decades-long career in the Northwest and for her persistence in pushing against obstacles all the way. We at Tacoma Art Museum have been aware of her work since the early 1970s and have shown her paintings in various exhibitions over the years. We are pleased to have several works in the collection, including Untitled (soft green), *The Conductor, Flamingos I Have Known and Loved*, and *Lucent Thicket*.

We honor her now with a solo exhibition and publication as part of our *Northwest Perspective Series*. From its beginning in 1992, this series has provided important new scholarship about the region's foremost artists. Our commitment to the series remains central to our mission of supporting the artists of the Northwest. I hope you will agree that Camille's career and accomplishments spring to life in *A Punch of Color: Fifty Years of Painting by Camille Patha*.

We are immensely grateful for Camille's support of *A Punch of Color* as it has evolved over the course of the last few years. She willingly opened her studio to us countless times and regularly visited the museum. I note her infectious enthusiasm and passion which propelled our staff forward. We are also indebted to her for lessons in resilience. Her dynamic career and compelling personal story demonstrate that commitment and hard work are critical to success.

The many lenders to *A Punch of Color* deserve our thanks as well. We appreciate their connection to Camille and her art, especially their willingness to live without her work for several months. Through their generosity, they provide us the opportunity to share how each of their works fits within the story of Camille's lifetime of painting. We thank Davidson Galleries in Seattle for their ongoing advocacy of our work with Camille. Gallery Director of Painting and Sculpture Jeffery Kuiper worked continually and graciously with our staff to help secure the loans for this exhibition.

I particularly wish to acknowledge museum staff for their expertise in realizing *A Punch of Color* with unflagging zeal and professionalism. Registrar Jessica Wilks and Exhibition and Collection Assistant Ellen Ito worked closely with Camille and photographer Richard Nicol to ensure high-quality images for this catalogue. Exhibitions and Publications Manager Zoe Donnell worked expertly to manage the details of this project. Curatorial Fellow Alison Maurer contributed a significant essay on the shifts in and legacy of institutional sexism in the Northwest since the mid-1960s, which affected artists like Camille. Maurer's insightful essay discusses the many barriers that still confront women in the arts. Curator Rock Hushka deserves special recognition for his dedication and close attention to Camille's career.

*A Punch of Color* is truly a special occasion for our museum. It commemorates our commitment to Camille and shares a lifetime of her art with our visitors. Through the work of our pioneering Northwest artists like Camille, we are reminded of our shared heritage and identity as denizens of the great Pacific Northwest.

## Artist's
## Acknowledgments

Camille Patha

I would like to offer my deepest thanks, gratitude, and respect for Tacoma Art Museum's many people who have made this exhibition and catalogue possible. Stephanie Stebich, Director, encouraged the development of a 50-year retrospective of my paintings. Curator Rock Hushka looked carefully at my career and worked to make this a comprehensive overview. I also greatly appreciate that he totally understands what I am painting. Curatorial Fellow Alison Maurer's essay provides a rigorous examination of the road I have traveled for the past 50 years. Kara Hefley, Director of Development, kept us all on track.

Richard Nicol is a photographer of excellence without whose images, the punch and vitality of this catalogue might be lessened. I also want to acknowledge the staff at both Daniel Smith Artists' Materials and Plasteel Frames and Gallery who helped me for so many years. I am thankful to Sam Davidson and Jeffery Kuiper at Davidson Galleries for their many years of dedication to support and promote me.

I would again like to thank Jon Shirley and remember his dear wife Mary, whose vast collection includes some of my works. My many friends and collectors who offered a lifetime of encouragement are so very important and dear to me. Lastly, I want to thank my husband, John, and my big bird, Paco. They are my very best advocates and friends.

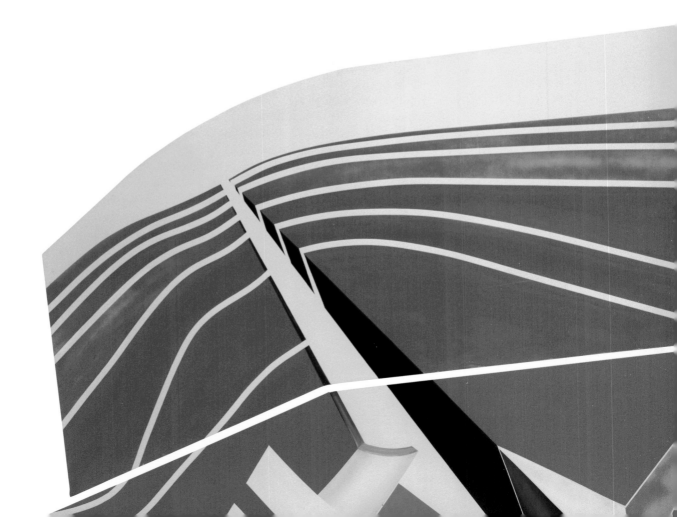

## Curator's Acknowledgments

Rock Hushka
*Director of Curatorial Administration*
*Curator of Contemporary and Northwest Art*

When I first met Camille Patha nearly ten years ago, I felt intimidated and uneasy. I was mystified by the exuberant colors of her recent abstract paintings. As I searched for a sense of meaning in her new paintings, Patha brashly demanded a studio visit. In front of me stood a woman who radiated an image of power and determination, truly remarkable even compared to the vast array of characters who inhabit the art world. I could feel that she was about to will a course of action into reality.

I am thankful that Patha patiently worked with me for so many years. We spoke often about abstraction and its potential to carry meaning. We reviewed her career. She eventually invited me to write a short essay for an upcoming exhibition, which I titled "Perpetually Forward." She expressed her appreciation for my work by choosing this same name for a small canvas. The related exhibition was later reviewed in *Art in America* and some of the paintings shown found collectors on both coasts and even in Hawaii.

I have come to fully appreciate Patha's journey as an artist and understand how she contributed to changes in the Northwest's art history. I have learned that Patha worked at the very forefront of artistic exploration throughout her career. Patha served as a trailblazer in the Northwest because she just wanted to paint, and I am grateful that she trusted me to help preserve her story.

Similarly, I thank Alison Maurer, Curatorial Fellow, for her outstanding contribution to this catalogue. Maurer fearlessly tackles an enormous topic—institutional sexism—with a balanced approach and sensitivity to its complicated and nuanced history in this region. Both Maurer and I are grateful for the artists who shared their experiences and thoughts about this topic. We are especially thankful for the input of Robin Held, former Deputy Director, Exhibitions and Collections of the Frye Art Museum and current Executive Director of Reel Grrls in Seattle. Held offered critical suggestions and insights that deepened key points of Maurer's argument.

I am also grateful to Tacoma Art Museum Director Stephanie A. Stebich. She saw in Patha a vitally important artist whose story is central to the last half century of the Northwest. Because of Stebich's vision, we have reconsidered the legacy of a true Northwest original, painter Camille Patha.

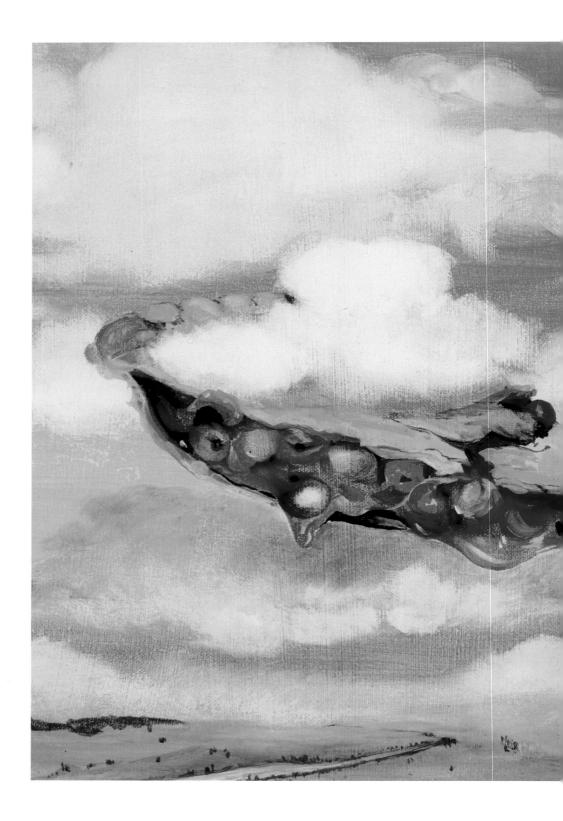

*All forms of beauty contain something eternal and something transitory; something absolute and something particular. The particular element in each form of beauty comes from the emotions, and as we have our particular emotions, we have our own form of beauty.*
—Charles Baudelaire

# Power and Paint
# The Art of Camille Patha

Rock Hushka

For fifty years, Camille Patha has dedicated herself to painting, first studying and then building a career as a painter. Painting has been her purest form of personal expression. She sees the world through the eyes of a painter, and her identity revolves around Patha *the painter* solving the problems posed by her studio practice.

Patha's career neatly spans the contemporary era of Pacific Northwest art—from the year after the 1962 Seattle World's Fair to the present day. In many ways, Patha's painting reflects the shifts in the trends and themes addressed by many of her colleagues. But Patha has remained staunchly independent of any allegiance to a particular style or a contained set of ideas. In fact, Patha's trajectory as an artist is complex, with dramatic shifts in style about every decade. Her voracious artistic exploration and fearlessness define her career as a painter.

Throughout all of Patha's variation, there are a few constant themes and ideas in her work. She is a colorist. She loves color, and it is her primary expressive tool. She understands perspective and spatial organization and manipulates the painted space masterfully. She paints large works. She makes expressions of strength and bravado. Her paintings always point toward symbolic self-portraits.

Patha was born Darlene Camille Taylor in Seattle in 1938. She was raised in blue-collar West Seattle. She describes herself as a difficult and willful child. But she was smitten with drawing and coloring like countless other children. Her mother quickly learned that Patha's affinity for drawing helped her focus. To settle her down or to keep her occupied for hours, Patha's mother would give her some paper, pencils, and crayons and know that her little girl would not get up to any mischief nor exhibit defiant behavior.

Patha began formal art lessons early, at the Amelia Hart Art School for Children in 1945 and 1946. Years later, at West Seattle High School, Patha studied drawing and ceramics with Gail MacDonald and Harry Beasley (1922–2013), respectively.[1] Patha married her husband, John, at the young age of 17. They met at church services; both of their parents thought that a church would be the best place to find a nice person to date. Camille and John recall they only went to one service, and since they found the right kind of person, they never returned. The newlyweds relocated to Arizona because John was assigned to the Luke Air Force Base near Phoenix. Patha enrolled at Arizona State University (ASU) and embraced the life of an art student with her typical vigor and excitement.

At ASU, Patha was encouraged to embrace her desire for strong color. She considers her time in Arizona as critical in developing her identity and ideas about painting. The experience utterly transformed her thinking, she says: "I was a Seattle girl. . . . All I ever saw was rain, moisture, and brown. And soft blue and beige, all the subtle colors that are the Northwest. I painted in those colors, I probably dreamed in those colors. But then I went to Arizona State University. . . . I saw the desert. I saw it in bloom. I saw sunshine. I saw hot,

hot reds. Hot yellows. I saw contrasts I never even dreamed of. I was 18 years old. I couldn't believe it. I began to paint."[2]

In 1959, Patha and her husband moved back to Seattle. He took a job with the Boeing Company, and she transferred to the University of Washington (UW) to complete her bachelor of arts degree. She completed her studies quickly (a dual track of art and education) and then spent the next three years teaching art at Chinook Junior High School. She knew that if she wanted to seriously pursue a career as an artist, she would need to complete a master of fine arts. She was accepted into the master's program in painting at the UW in 1963.

Patha was challenged during her time in graduate school. Her painting style and color palette were neither embraced nor encouraged by most of the UW's painting faculty. Patha describes the experience as traumatic: "We were squeezed. We were pressured. We were pointed in certain areas we didn't necessarily want to go. However, we complied because we wanted the degree and we wanted all the things that came after the degree." She elaborates: "I brought my colors with me. I painted wonderful loud oranges and reds and greens. . . . [But I was told] 'You need to make them a lot more soft, a lot more brown, a lot more blue, and a lot more dark. Your contrasts are pretty wild. You better soften them.'"[3]

The training at the UW was rigid, a melding of traditional studio methods, with only the slightest influence of the thinking being ushered into the universities by the burgeoning counterculture. At this time, men dominated the university's painting department. Viola Patterson (1898–1984), the wife of Ambrose Patterson (1877–1966), a professor in what was to become the School of Art who retired from teaching in 1947, was the solitary female painting professor. The next female professor, Karen Ganz (born 1963), wouldn't be appointed until twenty years later, in the late 1980s. This overwhelmingly masculine culture and its wider implications for Patha and other women artists in the Pacific Northwest are addressed in Alison Maurer's essay for this catalogue.

Patha was taught to paint expressively if, to her mind, blandly and mutedly. She describes the style she was forced to adopt as "slash and dash." Her recollections are that the style was all "brushy brush movement. But it wasn't making the statement I wanted to say."[4] Yet, when asked for further clarification, she admits that her experience was far more complicated and critically necessary for her future development.

Patha fully credits the UW program for her discipline in the studio. She learned to embrace a commitment to the hard work of painting and developed the ability to think through problems "like a painter." Contrary to some of her criticisms of the program, she also found encouragement from some of the UW faculty. She fondly recalls the good nature and experimentation that painters like Spencer Moseley (1925–1998) and Alden Mason (1919–2013) instilled in their students through lessons and by the example of their own careers.[5] She remembers Viola Patterson as kind and gentle, but elderly and with a limited appetite for experimentation. Patterson was influential for Patha in that she encouraged a relationship with painting that explored the lusciousness of the medium. For instance, Patha became enchanted with Patterson's tendency to set purples and blues against white to make them more vibrant.[6]

Patha also discovered the lure of the art world outside of the Pacific Northwest. Visiting artists to the UW School of Art, including Charles Cajori (born 1921) and Herbert

Siebner (1925–2003), opened her mind to the possibility that painting was wide open for her.[7] Yet the legacy of her graduate studies remains fraught with harsh memories. Patha tells of encountering Wendell Brazeau (1910–1974), one of her former instructors, at a social gathering after she had graduated. Brazeau, whom Patha remembers as a rigid painter but an interesting thinker, asked her, "Are you still painting?" Patha retorted quickly, "Yes. Are you?" much to the delight of his wife.[8] This brief but sharp encounter reveals Patha's independence and her refusal to allow a single person to deny her advancement as a painter.

After she graduated, Patha broke free from the stifling instruction imposed by the formalists. "When I came out of the university, I was a rebellious child of painting," she says.

> I didn't want to suppress my color, and my color began oozing out of my ears. Color came everywhere. Color came with the blacks. Color came with the blacks and whites. Color came with the soft blues. Color came with everything. And so I've always been a colorist. Color makes a statement about freedom, about humanity. It makes a statement about anguish and about joy. If it's very boisterous and bright, it doesn't necessarily mean you're happy. It may mean you're really angry and upset. It's the journey. The whole journey of color is extraordinary. And, I never cease to be fascinated by it. I can think about color all day and all night and never tire of it.[9]

This exuberant embrace of color marked Patha's early career. Works such as *Big Red* (plate 1) and the untitled works on paper (plates 2 and 3) reveal how color oozed and how she began to control this tendency. These three early works express her impulse toward complex compositions and show how she began to synthesize her lessons in abstract expressionist practice with her overwhelming and burning desire for personal expression. Her style also shows her determination to master the main focus of the region's key artists—Mark Tobey (1890–1976), Morris Graves (1910–2001), Paul Horiuchi (1906–1999), Kenneth Callahan (1905–1986), and Guy Anderson (1906–1998). She molds their gesture toward calligraphic imagery and oblique references to Northwest Native American formlines into her own expressive vehicle.

Her career began with immediate successes. Her works were included in Seattle Art Museum's Northwest Annual exhibitions in 1964, 1965, 1966, and 1968. She was included in Bellevue Art Museum's Pacific Northwest Arts and Crafts Fair in 1964, 1965, and 1968, winning honorable mention in 1964. She was also invited to exhibit works at the Otto Seligman Gallery soon after graduate school, in 1965. At this time she was painting works like *New Purpose* (plate 4). Patha began to abandon overall abstraction and eased into a figurative mode. The figure, almost her first self-portraits in their way, emerges from the depths of the picture plane and slowly comes into focus.

In the late 1960s, Patha traveled to New York City and experienced for herself the art described by Cajori and Siebner. She returned fortified with confidence and the desire to change her painting. First, she abandoned her expressionist brushwork for hard-edged abstraction. Second, she discovered a fascination for acrylic paint. Because acrylic was fairly new and most leading artists in New York had begun to work in acrylic, she too wanted to master it. She quickly learned that acrylic paint is, as she gleefully describes, belligerently flat and lacking in any transparency. But the paint is easy to use, dries quickly, and emits no toxic fumes.

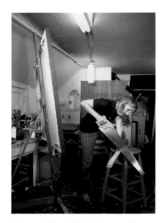

Figure 1. Camille Patha working in her studio in Seattle, circa 1971. Courtesy of the artist.

She began to paint on irregularly shaped canvases, often two shapes that combine to form a single composition. Her work simultaneously began to reference landscape or other potential spatial arrangements. *Space Game* (plate 5) creates an illusionary spatial recession that is wholly artificial. The composition results in a complex series of related geometric forms, each panel nearly complete in itself but with the pattern and relationships amplified by the diptych format. This style quickly attracted positive critical attention. *Space Game* was selected for the Washington State art pavilion at the Osaka World's Fair in 1970. Patha was the youngest of the 38 artists included in the exhibition.

That year was extraordinarily important for the young painter. Her work was again included in the Northwest Annual at Seattle Art Museum and the arts and crafts fair in Bellevue, as well as in the exhibition *Young Artists of Washington* at Tacoma Art Museum. Patha had become a leading Northwest painter (figure 1).

Patha further developed her ideas about shaped canvases and spatial forms with works like *Boxed Lunch* (plate 6). She shed the formalities of pure geometry and began to introduce narrative and autobiographical imagery. She also began her first gestures toward surrealism. *Boxed Lunch* is an oddly quiet painting, composed largely of expansive blue skies above a still pond, with an abandoned picnic lunch at the edge of an empty golf course. Upon closer inspection, the quietness gives way to a sense of entrapment. The child flying the red kite is about to run into three parallel walls. Patha camouflaged the walls as blue skies, but they are formidable barriers nonetheless.

Patha now admits that the walls of *Boxed Lunch* were manifestations of her feelings about the limits of her career growth.[10] The barriers are those she felt as a woman painter, struggling to advance her career, and they began to give form to her sense of limitations imposed from the outside. She would use this sense of containment as a motif for expressing how she would overcome both external limitations and internal doubts. She would fortify her identity as a dedicated and strong-willed painter.

"I want it [surrealism] to be very beautiful," she says, "very still, very intriguing, a little dangerous, a little sexual, a little wonderful—all the things that painting and life hopefully give to us."[11] The surrealist approach offered Patha possibilities to make direct statements couched in a free-flowing stream of consciousness. She would discover that she had a lot to express about herself, about women, and about painting. In their surrealist guise, her statements did not seem didactic or shrill but swept her viewers into alternative visions of the world.

*Pie in the Sky* (plate 7) is Patha's statement about her early successes and a message to her detractors. She was clearly enjoying her first major milestones as a painter. This small canvas gives form to the vision of reaching beyond one's obvious potential. The painting's soft brushwork and the slice of cherry pie, partially obscured by the fluffy clouds, triumphantly declare that Patha has begun to achieve her dreams and hint that such dreams are no longer out of her reach.

Still, there was a dark undercurrent to her career trajectory. As she began to develop her surrealist body of work, Patha became increasingly aware of limitations encroaching upon her. She felt boxed in by her gender. For years, she refused to sign her full name on her paintings and entry forms, giving only her initials. She assumed that "D. C. Patha" would

be taken for a man. Women artists simply did not paint so boldly, so strongly, so confidently, so absent of gender cues. Patha retells the moment when she was unmasked:

> I was entering these shows and signing only my initials. I was winning the competitions. One time, a gallery attendant was taken aback [when I presented my work], and a brisk back-and-forth ensued.
>
> "You're Patha? Oh my God, you're a woman."
>
> "Of course, I'm a woman."
>
> "But you paint just like a man."
>
> "No, I don't, I paint like a painter."[12]

With this conversation, Patha's world changed and her determination strengthened. She became known publicly as a woman, no longer as a painter. She felt betrayed and that her hard work and accolades had been diminished: "So, there's the essence of it right there, you see. You paint like a man: paint them big, paint them huge, a manly painting. I paint like a painter. I realized at that point in time there was a difference between the men and the women. At that point in time, I realized I was a protofeminist. I had no idea there was a difference. I thought I was one of the painters, one of the boys or girls. There was a difference."[13]

When pressed on how she responded, she insists that she returned to the studio with renewed fervor. Although she would make the acquaintance of art historian and artist Judy Chicago (born 1939), who proudly proclaimed her feminism, Patha focused on her own paintings. She refused to read the new feminist texts: "I was living it. [Those texts] would confirm my situation as an artist in Seattle."[14]

Patha rebounded by painting brick walls. Her work became solid, certainly symbolically and almost literally. Bricks became a symbol of strength, power, and impenetrability. They are weighty, meticulous, and ordered.[15] Not content to paint obstacles repeatedly, Patha sought metaphors for how she would overcome such barriers. "What can I do to bricks to make them not bricky?" she was thinking. "I made them transparent. I put holes in them. I put landscapes behind them. I talked about, basically, what women can do, what they are involved in."[16]

With *The Conductor* (plate 9), Patha demonstrated how the walls could be dissolved. She painted the bricks both firmly mortared into place but also floating as individual bricks in a band across the top of the composition. She also included bands of levitating apples and pears, alternately solid and transparent. Clearly echoing the Belgian artist René Magritte (1898–1967), Patha painted her own symbols of hope and clarity. Her technical mastery allowed her to articulate a powerful statement of defiance and her own sense of accomplishment. For the artist, this was a new style, and one that only she was exploring.

Patha made deeply colored, heavy, solid bricks and brick walls the central motif of her paintings for years. In *Walled Venus* (plate 10), she transformed Botticelli's iconic Venus into a symbol of feminist resistance. Patha elucidates, "I multiplied her across a brick wall, and I walled her in and I made her strong. I made her walled and unreleasable. It's a statement about females and about our strength and our lack of escape, as it were."[17] In Patha's painting, the multiplied, ossified Renaissance Venus stands indestructible within a temple

that links Patha's personal experience to the grand arc of art history—her statement on how she mastered the Old Masters.

The wall motif overtly symbolizes her sense of identity in the evocative and mysterious *An Honest Self-Portrait After 1974* (plate 11). Using her own silhouette to frame the scene, she paints a luscious, clear sky with ripe cherries dangling above a brick wall and with evidence of a lush garden reaching just above the top layer of bricks. The brick wall ends at her shoulders and her head is fully above the masonry, indicating that Patha has resolved, literally rising above, the psychological walls within. She has fought through her internal struggles and found the rewards, gem-like and delicious—the first fruits of summer. She was satisfied that her career and her painting were maturing.

Her confidence was the result, in part, of her first trips to Europe in the early 1970s. She experienced the art and architecture that she had only studied through books and lectures. She saw thousands of years of buildings, sculptures, and paintings in Italy, France, England, and Spain. She came back filled with inspiration to create her own versions of classical beauty. She began to synthesize her new knowledge with her own experiences and ambition.

The most refined example of this synthesis is her painting *Generalife* (plate 13). The work melds the unlikely combination of a fruit still life, a sunset over Puget Sound, and the gardens at the Alhambra, called the Generalife or Jinnah al-Arif (Gardens of the Architect).[18] Patha remembers her visit to the Alhambra as awe inspiring and life changing. She saw beauty made manifest in the gardens and the architecture. She was dazzled by the complex geometries and repetition of the sophisticated patterns. With her *Generalife*, she references the beauty of the Alhambra as a faint gate through which to see the Pacific Northwest and the still life. Considering the prominence of the cherries in her previous self-portrait, it is tempting to see the scattered cherries and lemons in the foreground as another articulation of her place in the Northwest landscape.

Patha's engagement with the Northwest landscape deepened in 1977 after an extended visit to the Washington coast with friends. Patha returned to her home overlooking Puget Sound with a severe case of "beach fever." Images of beaches and oceans thereafter replaced brick walls in her work. The openness of the horizon and infinite volumes of water dominated her paintings for the next few years. Patha found that the scale and power of the ocean offered a more authentic expression of her sense of herself as a painter than did copies of European artifacts. Reviewing Patha's first gallery showing of her beach images, art critic Diana Bock noted the psychological impact of these new works: "At her best, Camille Patha's works are vivid evocations of the primal age of this—or another—planet, and symbolic at the same time of the ever-shifting, undiscovered territory deep within the human mind. Their depiction of blooms of luminescence emanating from far distances down strange pathways, or from deep within black-white cubicles on empty shores, leave an after-image that glows on the viewer's retina for some time."[19]

Patha did not entirely discard her surrealist gestures. An emphasis on one-point perspective and geometric arrangements allowed her to stay within a kind of painting tradition, for instance, echoing the arcades of Giorgio de Chirico (1888–1978). Paintings such as *Passages* and *Beach Triptych* (plates 12 and 14) became her new self-portraits. In them

she replaces the wall with the pathway or dock, leading to the uncontained vastness of the artist's imagination. These represent her movement forward into something unknown.

Patha's success of the 1970s culminated with her first retrospective exhibition, *Camille Patha: A Decade, 1968/1978*, at Bellevue Art Museum in 1979. Writing for the catalogue, art critic R. M. Campbell observed,

> Patha can be evocative without being provocative. She winks her eye, bends her finger, and bids us to enter her seductive terrain of checkerboards, dreamy landscapes, over-ripe pears, classical arches, endless skies. It is not so much that she promises us any-thing of substantive or concrete value, but rather if we allow ourselves the freedom to follow the byways of her fertile imagination, we will embark on a pleasant, and perhaps surprising, journey into the unconscious.[20]

In the 1970s, Patha emerged onto the Seattle art scene and found critical and mar-ketplace success. Her work was reviewed regularly by the *Seattle Times*, the *Seattle Post-Intelligencer*, and *Argus* magazine. She showed frequently at Seattle Art Museum and the Pacific Northwest Arts and Crafts Fair. She was the first woman to receive the First Prize Award at the arts and crafts fair. The Boeing Company, Seattle First National Bank (now fondly remembered as Sea-First), Safeco Corporation, and Pacific Northwest Bell Corpo-ration, as well as Bellevue Art Museum and Tacoma Art Museum, collected her paintings. Patha cycled through gallery representation from Seligman in Seattle to Collector's Gallery in Bellevue and then to Gordon Woodside in Seattle. By any measure, Patha was a promi-nent Northwest painter, propelled by her strength and fearlessness.

In 1980, Patha moved away from traditional landscape formats and back toward florid surrealistic expression. *Genesis* (plate 15) is a science fiction–like blossom with mul-tiseeded, split fruits suspended in the front picture plane, with a distant mountain range in the background. Patha complicated the painting by balancing the orb-like forms across the top of the canvas with the large oval-shaped splash of light across the bottom. These layers suggest that she was beginning to think about new ideas, emphasizing the careful articulation of a floral specimen over the depiction of a realistic landscape. Thirty years later, Patha admitted the crux of this painting to be its luxurious sensuality and dangerous connotations of feminine desire.[21]

A year later, in 1981, Patha painted *Flamingos I Have Known and Loved* (plate 16), intro-ducing the bird form as an integral compositional element. Incorporating influences such as Judy Chicago's *The Dinner Party* and the flowers of Georgia O'Keeffe (1887–1986), this painting is a careful arrangement of blooms, flattened and pulled to the front of the pictorial space. The ground of the canvas is covered by a lace pattern, stenciled from a reclaimed textile. Patha slyly inserts a cluster-like form (perhaps a nod to the ubiquitous and invasive, but delicious, Northwest blackberries) inside the massive orchid/lily bloom. As she had done in *An Honest Self-Portrait After 1974*, Patha again used a gem-like fruit as the focal point. Every aspect of *Flamingos I Have Known and Loved* is a powerful declaration of her femininity: the carefully articulated blossoms, the sophisticated pink ground, the highlights on the fruit, the sensual curve of the flamingo's neck, and the drops of dew falling off the tip of the yellow petal. For the first time, Patha overtly declared her power as a female painter.

Birds became significant in Patha's life beginning in 1983. Although she had painted birds earlier in *Boxed Lunch* and *Flamingos I Have Known and Loved*, Patha adopted her first pet bird in 1983 when her husband, John, rescued a juvenile crow with deformed feet. The couple nursed the bird to health and it lived with them for twelve years. This pet, which they named Crash because it had a tendency to fly into windows, opened Patha's mind to a new and powerful motif. She and John would later adopt fancy chickens, Henny Penny and Arturo Toscanini, and a blue macaw named Paco.

In 1985, Patha finished *Self-Portrait* (plate 17). Once again, Patha melded an unusual set of visual images to push her painterly vocabulary forward. She represented herself as a magnificent and graceful egret set in a deeply receding space, with its black-and-white checked floor and walls depicting pinkish beach sunsets. Patha described her thinking about this self-portrait, saying, "I'm part of earth, I'm part of creation, I'm part of all natural things."[22] This image became an accounting of the past decade of her painting: the beach scene with an emphasis on the single-point perspective, the move toward stronger color, and a symbolic representation of herself.

*Ancestral Spirit Bird* (plate 18), also painted in 1985, distilled Patha's tendency toward layering and color transparencies. This painting, which includes a ghostlike silhouette of an egret, was her first fully expressed attempt at layering large compositional elements, and it hinted at her work with transparency that would become the hallmark of her later painting style. In this early version, Patha layers boxes of landscape over a slightly abstracted cloudy sky. Using the palette of the 1980s (think blue velour sweaters), Patha demonstrated a remarkable ability to advance her painting style idiosyncratically but with a keen awareness of the trends and styles swirling around her.

By the late 1980s, Patha had exhausted her interest in surrealism and realist imagery. "I had become very disenchanted with the surrealistic approach," she recalls. "One statement was all I could get out of each painting. Just one thing . . . I wanted something better and bigger and more important. So, I began to experiment with craft, using fabrics, using little jewels, gold foil, silver foil, gold leaf, and silver leaf. It was a break."[23] She willingly shed one painterly vocabulary to discover and master another. She believes that this kind of development is absolutely necessary for an artist: "Your work better be changing. If it's not, you'd better do something about it. Evolving. I call it natural growth."[24]

Figure 2. Camille Patha, *Raven-That-Stole-the-Sun*, 1995. Monotype with mixed media and gold leaf on paper, 53 × 37 inches. Courtesy of the artist.

This period of her art is marked by her deliberate move away from pure painting (paint on a rectangular canvas) and into mixed media and printing. She brought her painter's eye and approach to these later works, with mixed results (figure 2). These works employ softer imagery and subject matter culled from mostly nature. She set aside complex vocabularies and inner narratives to celebrate the natural world.

Her new style was well received outside of traditional art circles. In 1989, she won a prestigious commission for the City of Des Moines, Washington, and the following year the Hilton Hotel in SeaTac selected her for a major commission to make art for the entire hotel. The Seattle Yacht Club hired her to illustrate a cookbook it published in 1990,[25] and the iconic Seattle restaurant 13 Coins asked her to make works for its SeaTac location.

By the early part of the next decade, Patha was beginning to feel the limitations of this line of experimentation. She began to realize she was unfulfilled as a painter. She wanted colors. She wanted to feel her brush moving paint across a canvas, and she wanted to think

about the world through the filter of painting. A final bit of encouragement came from a conversation with the art critic Matthew Kangas, who strongly encouraged her to start painting with oil paints again.[26]

She returned to her studio with a vengeance, and she began to produce spectacular paintings, with layers of brilliant colors that were suspended in an indeterminate picture plane. This new work emerged from her renewed interest in the expressive possibilities of color. Describing her approach to the new paintings, she told Kangas, "I start out on my palette. I sit in my chair and look at the canvas. I have the colors in my head and I have in mind that I want a portion of it to be light and a portion to be dark."[27]

Using the transparencies afforded by oil paints, Patha filled the canvases with areas of strong color, adding layer upon layer. Her interest in color was the driver for the compositions: "One passage talks to the next passage. One color talks to the next. In fact, it's not color unless it's next to another color."[28] She allowed the adjacencies and geometries to develop organically, trusting in her decades of experience. The layers allowed her to generate a tension between the flatness of her forms and the unmistakable suggestion of receding space. The titles of these works confirm the paramount importance of color: *Launching Violet*, *White Arrival*, and *Bordeaux Passage* (plates 19–21).

These paintings were a breakthrough for Patha. She shed the painterly tightness and precision of her surrealist phase but maintained her expert technical level. She avoided the "brushy brush" qualities of her earliest abstractions in favor of thinly applied paint, yet the sense of her hand remains strong. The paintings from this phase of her career give a sense of utter joy and a desire for exquisite beauty. They feel like an exuberant expression of Patha's confidence in her love of paint, color, and life.

In her studio, Patha quickly doubled down and refocused her efforts on the core themes of transparencies and strong color. She refined her forms and started to sharpen the edges. She exerted control over the liquidity of the paint and began to paint complex and heavily layered geometries. This body of paintings stands out for the works' very boldness. It is almost as if she returns to the late 1960s and allows her colors to ooze again. Rejecting diffuse and soft, she uses the very un-Northwest palette of shocking ranges of orange, yellow, fuchsia, turquoise, peach, and green.

Patha recognizes that these paintings function as a summa to her career. In specific, she offers insight into *Yella Thrilla* (plate 23): "Look at how one passage weaves into the other. How it's really, really powerful. You read it left to right. I'm talking about the journey, the journey of life. It's all about our lives. It's about my life. It's about my communication with you to try to understand what I'm trying to say. It's intricate, it's beautiful, it's sad, it's exhilarating, it's wonderful. It's all the things we are in our lives."[29]

A clearer representation of her life journey may be seen in the emphasis on tumbling circular motifs present in this later body of work:

> On the one hand, the forms suggest Patha's restlessness and aesthetic voracity. While the circles clearly help illuminate Patha's full command of the notion of the "total composition," they may be more important with their implied suggestion that Patha refuses to be satisfied with the status quo. On the other, the circles move the eyes around the canvas with machine-like precision. The movements provide direction towards a goal, hinting at a sense of journey or determined purpose.[30]

A second major development in this new body of paintings is the appearance of the "X" form. She sees the X as a graffiti tag, a symbol from traffic signs, a regular device used in advertising logos. She realizes that the letter is a powerful but rare one in the English language. She understands that those unable to write their names use it as a signature on legal documents. She is also quick to say, "X marks the spot." As a painter, she comes to this symbol by the intersection of forms, almost by accident.[31] All of these meanings make the X irresistible to Patha. The motif asserts her authority and experience as an artist. With it, she marks her sense of achievement and signs her work.

She continues with the X in her most recent paintings, *Punch* and *Self-Portrait at Midnight* (plates 27 and 28). In these newer works, she synthesizes the most successful and intriguing elements of the complex layers found in her paintings of a few years earlier, also refining the beauty and effect of the transparencies. In *Punch*, she splatters black paint across the canvas to make her X. In *Self-Portrait at Midnight*, the X almost disappears behind the central coral red forms. But in both works, Patha deftly downplays hard edges and returns to exploit the pleasure of transparent colors.

These two late paintings, but especially *Self-Portrait at Midnight*, return to Patha's ability to push into a deeper realm of self-reflection. She finds a new way to express beauty and her self-confidence. The paintings distill the essence of her quest as a painter: an articulation of her own sense of her power. These two recent works engage all of the painterly qualities that she has sought for decades. The colors are strong. The compositions are energetic and enigmatic. The titles are evocative of her intent. She controls the transparencies and gradations, marking her authority as a senior artist and deftly moving into a body of work that rekindles her interest in abstraction. Such self-examination reoccurs at key moments in her career: overtly in *An Honest Self-Portrait After 1974* and the 1983–85 self-portrait and symbolically in paintings such as *Pie in the Sky*, *Generalife*, and *Flamingos I Have Known and Loved*.

As an artist committed to her practice, Patha is remarkable for her fifty years of painting. In each period, she refines her thinking and style and then moves on to the next. She has made these decisions carefully and thoughtfully, in service to personal expression. She reflects, "I've been strong. I've been willful. I was a difficult child. . . . I've been a difficult person, and I'm sure I've been a difficult wife. But, I'm me and my work is sincere, and I am very, very driven."[32] As an artist seeking to articulate a unique personal identity, she is virtually unparalleled in the region. She has been a trailblazer, reshaping the possibilities for future painters, and she continues to produce paintings of exceptional beauty and power. With half a century of experience and life lessons to share, Camille Patha remains a painter.

## Notes

*Epigraph:* Quoted in Deloris Tarzan, "The Weightless World of Camille Patha," *Seattle Times,* February 24, 1976.

1   Matthew Kangas, *Camille Patha: Geography of Desire* (Salem, OR: Hallie Ford Museum of Art, Willamette University, 2006), 19.

2   Camille Patha, "Age of Feminism," artist lecture, Tacoma Art Museum, March 29, 2010, recorded in *Camille Patha: The Age of Feminism*, DVD (Issaquah, WA: Bennett-Watt HD Productions, 2010).

3   Ibid.

4   Ibid.

5   Conversations with the artist, January 6 and July 18, 2013.

6   Conversation with the artist, July 18, 2013.

7   Kangas, *Camille Patha: Geography of Desire*, 20–24; conversation with the artist, January 6, 2013.

8   Conversation with the artist, July 13, 2013.

9   Patha, "Age of Feminism."

10  Conversation with the artist, July 18, 2013.

11  Ibid.

12  Conversations with the artist, 2011–13; Patha, "Age of Feminism"; Camille Patha, "A Painter's Journey," artist lecture for Women Painters of Washington, Seattle Art Museum, March 14, 2012, DVD recording (Issaquah, WA: Bennett-Watt HD Productions, 2012). Patha does not remember the date of this exchange with the gallery clerk, but given her critical acclaim and reputation in the mid-1970s, it seems likely that this event happened before 1974.

13  Patha, "Age of Feminism."

14  Conversation with the artist, July 18, 2013.

15  Patha, "A Painter's Journey."

16  Patha, "Age of Feminism."

17  Ibid.

18  Gabrielle van Zuylen, *Alhambra: A Moorish Paradise* (London: Thames & Hudson, 1999), 57–69.

19  Diana Bock, "The Surrealist Road to Beach Fever," *Argus*, November 3, 1978, 9.

20  R. M. Campbell, "Camille Patha: A Look," in *Camille Patha: A Decade, 1968/1978* (Bellevue, WA: Bellevue Art Museum, 1979), n.p.

21  Patha, "A Painter's Journey"; Patha, "Age of Feminism." When the Jundt Art Museum at Gonzaga University sought to acquire this painting, Patha asked if they understood the sexual connotations. To her delight, the curator responded, "My dear, we Catholics reproduce too."

22  Patha, "Age of Feminism."

23  Ibid.

24  Patha, "A Painter's Journey."

25  Seattle Yacht Club, *Extraordinary Cuisine for Sea and Shore* (Seattle: Peanut Butter Publishing, 1990).

26  Patha, "A Painter's Journey."

27  Kangas, *Camille Patha: Geography of Desire*, 57.

28  Patha, "A Painter's Journey."

29  Patha, "Age of Feminism."

30  Rock Hushka, "Camille Patha: Perpetually Forward," in *Camille Patha: Forever Forward* (Seattle: Davidson Galleries, 2011), 5–7.

31  Conversations with the artist, March 19, 2012; May 23, 2012; and February 14, 2013.

32  Patha, "Age of Feminism."

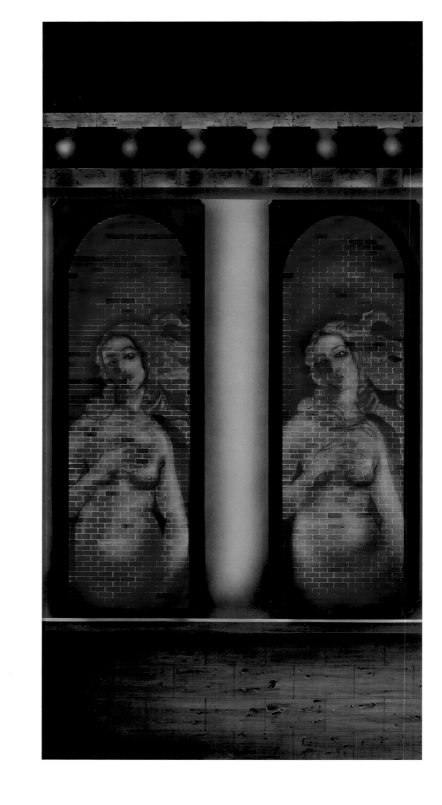

# Contextualizing Camille
## Women Painters and the Legacy of Institutional Gender Bias

Alison Maurer

Camille Patha (born 1938) signed her work "D. C. Patha" for many years as a way of concealing her gender and thus increasing her chances of receiving awards and critical attention. To her, the disguise offered clear benefits.[1] Artists from generations before and after echo this same experience. Kathleen Gemberling Adkison (1920–2010), one of ten women included in the 1962 Seattle World's Fair *Northwest Art Today* exhibit, did not use her first name because women painters were not considered serious painters.[2] Karen Ganz (born 1963), a painter working a generation after Patha, similarly used just her first initial in order to compete more equally with her male contemporaries.[3] These women painters' experiences are far from unusual and reflect strategies to circumvent systemic gender-based inequities.[4] The Pacific Northwest—Camille Patha's home—provides an interesting context for this disparity, revealing region-specific impacts on women artists and evidence of global gender discrimination.

In 2012, for the first time, a woman achieved the highest rank of professor in the Painting and Drawing program at the University of Washington (UW), an important institution in the Northwest for training, supporting, and employing artists, as well as being the school where Camille Patha earned both a bachelor of arts and a master of fine arts.[5] Established in 1916, the UW's department of painting and design (now the School of Art) has an impressive record of well-established and skilled painting professors, key contributors to the region's art history, including Jacob Lawrence (1917–2000) and Ambrose Patterson (1877–1966). Adding Professor Ann Gale (born 1966) to this list marks progress in the fight for equal opportunities for women but also begs the question of why it has taken 96 years to get to this point (figure 1). Women painters' experiences at the UW in the later half of the 20th century reveal systemic, institutional gender discrimination against women painters and their use of "feminine" styles, as well as harmful double standards that are implicated in the regional and global exclusion of women from mainstream art history. Patha's biography, as told in Rock Hushka's essay in this catalogue, is one example of what it was to be an emerging female painter in the 1960s and 1970s; her experience grounds the following stories, which themselves reveal the continuities and shifts in the art world since Patha entered the field. It is time to honor the voices of artists like Patha who have experienced discrimination and to reenergize the push for institutional equality for all artists, regardless of gender.

There is no singular female experience. Each individual has her own story, however much it might overlap with another's, and each is deeply affected not only by gender but also by race, class, sexuality, and geography, among countless other factors. It is impossible to speak to these wide-ranging experiences in their entirety. The stories told here are of women artists in the Pacific Northwest with ties to the University of Washington, who see the arts either as a career or as a lifelong pursuit. They are artists who came up a generation after Camille Patha. This focus reflects only one reality of the art world, but one that profoundly informs our present moment.

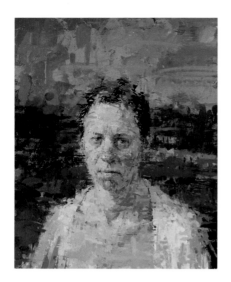

Figure 1. Ann Gale, *Rachel with White Robe*, 2011. Oil on canvas, 14 × 11 inches. Courtesy of the artist.

The University of Washington is important to consider for its role as an academy—a place of history making, training new generations of artists, and championing the careers of the artists it selects. As such, it carries a heavy burden in the pursuit for equal opportunities. The support, praise, networking, and backing from professors in pushing student artists toward success cannot be undervalued.[6] The university is also an employer, with a significant role in deciding whom to hire and thus in providing financial support and professional networks. When considering the larger question of women artists and their achievements as compared to their male counterparts, it is important to understand the power of the university to influence the development, training, and careers of female (and male) artists.

The University of Washington is tied to the careers of many of the more established female artists in the region, such as Ann Gale, Karen Ganz, Layne Goldsmith (born 1950), Mary Lee Hu (born 1943), Viola Patterson (1898–1984), Ramona Solberg (1921–2005), Barbara Earl Thomas (born 1948), and Patti Warashina (born 1940), in addition to Camille Patha. The stories of some of these artists reveal how women pursuing painting as a career struggled against a system that historically and structurally did not support them. The UW is not alone in its history of gender inequality. Fay Jones (born 1936), a student at the Rhode Island School of Design in the mid-1950s, experienced a climate that was "particularly harsh for women artists . . . as they tried to bear up under male-imposed rules."[7] But for the purpose of examining the opportunities and obstacles for women in the Northwest, the UW, with its major role in shaping the history, tastes, and ideas of art in the region, deserves close examination.

Institutional marginalization has resulted in part from the historical assumption that women, purely on the basis of their sex, cannot be painters. Overt discouragement of female painters illustrates this ingrained opinion. Karen Ganz, former assistant professor of painting, recalls occasions at UW meetings and outside social events where women, but never men, were spoken of as being "too beautiful to be serious painters."[8] Similarly, the often-referenced and historical compliment, "She paints like a man," invalidates women as artists in the guise of praise.[9] Camille Patha's retort, "I paint like a painter," in response to hearing that very comment from a gallery attendant, epitomizes the gender bias that women artists had to overcome in order to receive equal respect.[10] Such encounters expose a culturally sanctioned assault on women's potential. If a female artist's work or career choice risks invalidation because of her sex, then the artist, from the start, is not allowed access to the opportunities available to men.

The marginalization of artistic styles categorized as "feminine" has added to the suppression of women painters' potential. Camille Patha and Judy Chicago (born 1939), an artist central to the evolution of feminist art and one of Patha's contemporaries, both studied under male professors who attempted to "beat [the] color out" of their work.[11] Both paint with bright and loud color palettes full of pinks, oranges, and yellows, colors often associated with femininity.[12] Singling out and discouraging "feminine" colors can instill in a student the sense of the female as inferior, a concept often learned at a young age that can lead to a woman's distrust of her voice. If women learn that their voices do not deserve equal respect, then they can be more likely to accept their marginalization and less likely to

Figure 2. Camille Patha, *Pink Venue*, 2007. Oil on canvas, 48 × 48 inches. Courtesy of the artist.

Figure 3. Judy Chicago, *Marie Antoinette*, from the *Great Ladies* series, 1973. Sprayed acrylic on canvas, 40 × 40 inches. Collection of Elizabeth A. Sackler.

challenge the status quo.[13] Professors in positions of power at the time of Patha's and Chicago's education, consciously or unconsciously, perpetuated this historical pattern of stereotyped gender bias. Patha and Chicago both moved past this discouragement and returned to bright palettes, expressing themselves in large, colorful paintings to this day (figures 2 and 3).

These dynamics have informed and shaped the male-dominated history of painting and thus the historically male-dominated painting departments in universities all over the world. In the case of the UW, the painting faculty consisted predominantly of men for years, in part because there were no new painting hires of any gender from the 1970s until the late 1980s. Jamie Walker (born 1958), associate director of the School of Art and a professor in 3D4M (the consortium of ceramics, glass, and sculpture), remembers arriving at the university as an undergraduate in 1976 and noticing that the painting department was entirely made up of men.[14] These professors, among them Francis Celentano (born 1928), Robert C. Jones (born 1930), Spencer Moseley (1925–1998), and Michael Spafford (born 1935), remained on staff for many years, most until retirement. With the exception of Associate Professor Viola Patterson, who retired from the painting faculty in 1966, a male-dominated environment would have also been the case during Camille Patha's time at the university.

In the 1960s, 1970s, and early 1980s, the UW was expanding in the growing fields of traditional craft mediums, ceramics, and fiber arts among them, along with printmaking, photography, design, and art history. The university actively employed female professors in these areas, including ceramicist Patti Warashina and jewelry artists Mary Lee Hu and Ramona Solberg. In fact, the UW has employed some of the most influential women in these fields. The university's intention to broaden the School of Art's curriculum meant that new painting professors were not hired until older professors retired.[15] After Jacob Lawrence was hired in 1971, no painting professors joined the faculty on tenure track until 1988.[16] This 17-year gap is partly to blame for the lack of women in the department.

The University of Washington has attempted to diversify its faculty—ensuring that women are present on hiring committees and instructing that, all things being equal, committees should fill diversity gaps—and it has made progress in other departments.[17] But the complete absence of hiring opportunities in the painting department is definitely implicated in the department's slow demographic shift. Karen Ganz (figure 4) joined the department in 1988, the first woman painter hired on tenure track since Viola Patterson.[18] After Ganz, the university hired a number of women painters, including Hanneline Røgeberg (born 1963), Denyce Celentano (born 1958), Ann Gale, and Helen O'Toole (born 1963). Gale and O'Toole were the only two women on staff in 2013 out of six Painting and Drawing faculty; and O'Toole, an associate professor (a tenured position), at that time was being considered for promotion to professor.[19]

The accomplishments of Gale and O'Toole are significant and after so many years mark a start of the Painting and Drawing program's shift toward equal gender representation.

The university's intention to recruit women faculty notwithstanding, structures persist that make this a challenging goal to achieve. Historical precedents and double standards contribute to preventing women from reaching positions equal to those of their male peers. Fiber arts professor Layne Goldsmith spoke on a panel for a university training sponsored by the provost's office, aimed at helping women achieve tenure at the UW; she remembers discovering that the bar was higher for women than men. In her understanding, to achieve tenure women were required to have more of each of the elements that play a role in tenure reviews (e.g., committee work). She recalls that this fact was discussed openly each year she participated in these trainings.[20] Karen Ganz's joke about this discrepancy is that a woman had to "be 10 times as good just to be rejected."[21]

For Goldsmith's own tenure review, the disparity she was most nervous about did not involve her exhibition record, teaching reviews, or service to the field, but rather the attitude of her colleagues in response to her tendency, as she describes it, to not "toe the line." In order to best advocate for opportunities for her students, she sometimes pushes the boundaries and works in unconventional ways. When it comes to tenure for all faculty, she sees obedience weighing more heavily in tenure reviews for women

Figure 4. Karen Ganz, *Grifter #2*, 1997. Oil on canvas, 84 × 72 inches. Tacoma Art Museum, Gift of Carol I. Bennett, 2001.47.4.

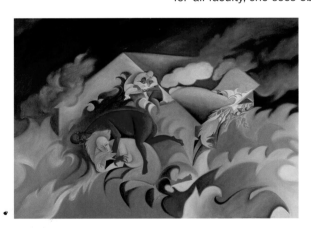

and noted an occasional tolerance for some of the long-term-tenured male professors' less normative behavior. Goldsmith remembers the older male professors who dominated the painting department when she arrived at the UW as able to get away with saying and doing more controversial things. These were written off as predictable ways that artists behaved, including one professor stating, "To stretch a big canvas you have to have a stiff member."[22] In her experience, and as seen in Karen Ganz's tenure review, behavior and personal politics play a critical role in the evaluation of women faculty members.

Karen Ganz completed her undergraduate degree at the University of California, Berkeley, under Joan Brown (1938–1990), a painter who achieved national success and instilled in Ganz the knowledge that she would need to be tough to suc-

Figure 5. Barbara Earl Thomas, *The Storm Watch*, 1988. Egg tempera on paper, 21¾ × 29⅞ inches. Tacoma Art Museum, Gift of Carol I. Bennett, 2004.34.1.

ceed.[23] In a male-dominated field, women had to assert themselves to achieve respect as equals. Painter Barbara Earl Thomas (figure 5), former executive director, now deputy director of the Northwest African American Museum, has seen this same struggle in her own career. Staying in line has been a major stumbling block for her. Others see Thomas as "unpredictable," she says.[24] While this was not unique to female faculty members at the UW (Jamie Walker remembers being called into the dean's office many times), challenging the university norms meant, for Ganz, particular obstacles in her tenure review despite substantial support from students and male and female faculty members alike, including

Walker. She recalls hearing that one professor on her review panel remarked that she "did not uphold the standards of the 19th century."[25] This comment marks the persistence of a male-dominated painting tradition, one that Ganz, who was part of a shift in the status quo, did not fit into. Ganz, Goldsmith, and Thomas have fought to achieve professional success within a world that struggles with women pushing boundaries but lauds the ingenuity of men who do.

The standards for tenure at the University of Washington were evolving in the 1990s, emphasizing the importance of a national reputation.[26] Unfortunately, the obstacles women artists face in achieving national or international recognition make these standards challenging to meet. Gender disparities in gallery representation and solo exhibitions are well documented. Between April 2012 and April 2013, East London Fawcett (ELF), a branch of the United Kingdom's leading advocacy group for gender equality, gathered information about the representation of contemporary female artists in London's galleries. Of the 3,163 artists represented by 134 commercial galleries, only 31 percent were women; 78 percent of the galleries represented more men than women. Of 133 solo shows in 29 noncommercial galleries in the city, 31 percent were by female artists; nearly a third of these galleries had no female solo shows at all but mounted numerous male solo shows.[27] Considering the *Guardian*'s statistics that 61.7 percent of undergraduates studying creative art and design in the United Kingdom from 2011 through 2012 were female, ELF's findings reveal not a lack of women pursuing the arts but a significant and systemic preference for male artists.[28]

Similar work done by the Guerrilla Girls, the feminist activist group that has been highlighting gender and racial inequalities in the art world since 1985, shows a comparable disparity in major US art institutions that has changed very little for more than two decades. One of the group's most powerful posters, updated every few years, pointed out in 2012 that "less than 4% of the artists in the Modern Art sections [of the Metropolitan Museum of Art] are women, but 76% of the nudes are female" (figure 6). The first version of that same poster, from 1989, reprimanded the Metropolitan Museum of Art because only 5 percent of the artists in the modern art sections were women, while 85 percent

Figure 6. Guerrilla Girls, *Do Women Have to be Naked to Get Into the Met. Museum?*, 2012. Courtesy www.guerrillagirls.com

of the nudes were female.[29] It is interesting to note that the percentage of women artists has gone down over time. While the situation in the arts may have changed slightly for women, this gender disparity remains a serious issue.

Though the Pacific Northwest art world differs from that of New York City or London in some ways, the regional numbers are not so different. A sampling of 20 of the larger commercial galleries in Seattle and Portland shows that women make up, on average, 37 percent of the artists represented.[30] In 13 galleries women make up between 30 and 50 percent of the total artists. Four galleries each represent less than 30 percent women, and only 3 galleries represent 50 percent or more, Grover/Thurston Gallery being the outlier at 70 percent women out of a total of 23 artists. While affected by its relative geographic

isolation in the United States, the Northwest nonetheless reflects the gender representation disparities present in the international art world.

Select museums in the Northwest have had some success in balancing the men and women represented in solo exhibitions.[31] Since the start of 2010, Seattle Art Museum has mounted 11 solo exhibitions of women artists out of 22 in total, a marked improvement from the 1983–2005 period: in that 22 years, out of 47 solo exhibitions, the museum's Documents Northwest: The PONCHO Series featured only 13 solo shows by women. Portland Art Museum has exhibited only 11 female artists out of 40 solo shows since 2010. Bellevue Arts Museum has shown 9 women out of 14 solo exhibitions, standing out in 2010 with 5 out of 5 solo exhibitions featuring women artists.

Tacoma Art Museum, having shown women artists in 5 out of 11 solo shows since 2010, and in 13 out of 24 Northwest Perspective solo exhibitions since 1992, is featuring a program similar to Bellevue Arts Museum in 2013 through 2014. In addition to A Punch of Color: Fifty Years of Painting by Camille Patha, exhibitions will honor the work of Z. Vanessa Helder (1904–1968), Jennifer Steinkamp (born 1958), Agnes Martin (1912–2004), and Matika Wilbur.[32] The programming at Bellevue Arts Museum in 2010 and at Tacoma Art Museum in 2013–2014 stands out because the shows are all women. It would not seem noteworthy if the featured artists were all men. Museums and galleries rarely tip the balance such that women significantly outnumber men. These years, while worth noticing, remain the exception. If women artists still face such challenges on a local level, establishing a national reputation and besting the odds in New York or London is likely even more daunting. For women like Karen Ganz, such an obstacle may mean achieving tenure or not.

The legacy of these imbalances is the exclusion of women artists from the narrative of mainstream art history, particularly in the field of painting. Layne Goldsmith, a professor at the UW since 1983, studied at California State University, Long Beach, where in one painting class in 1968 the young male professor presented only male artists as examples of great painters. When she asked why he never spoke about women painters, he nervously responded that there have never been any great women painters. Goldsmith thought, "How can I do this if there have never been any great women painters?" "Who am I kidding?"[33] To her, becoming a great painter would mean overcoming the significant limitations of her gender, paving the way for women for the first time.

A woman of Layne Goldsmith's or Camille Patha's generation seeking a career in painting in the Northwest faced a strongly male-dominated art world, specifically the legacy of the Northwest school, a stylistic movement influenced by the regional landscape and non-Western religions, whose most notable members were Guy Anderson (1906–1998), Kenneth Callahan (1905–1986), Morris Graves (1910–2001), and Mark Tobey (1890–1976).[34] Lois Allan, in her survey of contemporary art in the Northwest, argues that "not since the time of the Northwest School has an ideological and stylistic identity been ascribed to the art of the Pacific Northwest."[35] While there have been a few group exhibitions focused on the contributions of women to the art history of the region,[36] the legacy of the male-dominated Northwest school continues to overshadow the role of any female artist in Northwest art history.

Not seeing a future for herself in painting, Goldsmith moved to fiber arts as a student, a field much more accessible to, indeed dominated by, female artists. In the 1960s and

1970s, the art form was burgeoning, not looking back to predetermined textile traditions but rather open to innovation. Fiber arts allowed Goldsmith to explore a medium without limitations imposed from within or without by the male dominance of art history.[37] Unlike the overwhelmingly male world of painting, fiber arts offered her opportunity and a future. Goldsmith has developed a successful artistic practice, achieved a full professorship at the UW, and today is the longest-serving studio professor at the university (figure 7).

While the importance of innovative women in traditional craft mediums is indisputable, the lack of women painters in mainstream art history is equally undeniable and its consequences are enduring. As recently as 2001, Judy Chicago noted that this absence of women from mainstream art history encourages the perception among young female artists that they have to break new ground, since they are unable to see who and what has come before. Chicago references historian Gerda Lerner's argument about "trained ignorance," in which women "are raised and educated to a male-centered perspective on the world and have no access to the information that would allow them to come into consciousness."[38] Learning the history of women artists over the centuries would help up-and-coming female artists to focus on their own voices, on steering their chosen field toward innovation overall, as in Goldsmith's case, rather than pushing first for the legitimacy of their work. While Chicago admits to progress in the acceptance of "female sensibility" in art, she describes these as "entry level" changes, noting minimal representation in permanent collections and major exhibitions.[39]

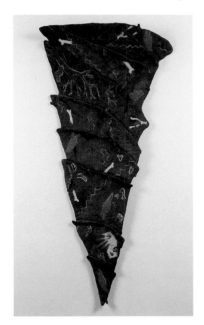

Figure 7. Layne Goldsmith, *Blackout*, circa 1986. Wool felt, 72 × 33 inches. Tacoma Art Museum, Gift of Safeco Insurance, a member of the Liberty Mutual Group, and Washington Art Consortium, 2010.6.44.

Gender bias continues to unduly influence discussions of women artists' place in Northwest art history. Texts that otherwise intend to honor the contributions of women reference male figures again and again as influences, teachers, spouses, and family members. These connections reflect reality and the legacy of an entrenched male-dominated social structure, as well as the necessary conditions for achieving success in the arts as a woman (e.g., networks and patronage are traditionally more available to men), but they simultaneously downplay the importance of the featured artist's work to the region's art history. Consider some of the most successful women artists in the Northwest: Kathleen Gemberling Adkison, studied with Mark Tobey; Fay Jones, married to painter Robert C. Jones; Viola Patterson, married to Ambrose Patterson; Barbara Earl Thomas, studied under Jacob Lawrence, Michael Spafford, and Norman Lundin (born 1938); Margaret Tomkins (1916–2002), married to painter James FitzGerald (1910–1973); and the list goes on. While relationships among artists are in no way unusual, and mentors are often critical to an artist's development, emphasizing the importance of male figures in a female artist's life reads more like an attempt to give legitimacy to her career rather than an effort to praise her work. These connections should not be ignored, but it is important to remember and reexamine the structures that often make these connections necessary to the success of a female artist and the resulting ways that scholars and institutions discuss them in their writing.

Many texts about women artists in the Northwest demonstrate the legacy of gender discrimination in the arts. Matthew Kangas, in one of the few books that highlights the contributions of women painters to the art history of the Northwest, nevertheless repeatedly mentions the men who influenced them. About Jacqueline Barnett (born 1935), Kangas

says, "She brings to mind gentler, earlier tendencies in Abstract Expressionism from the 1940s and extends William Baziotes's, Adolph Gottlieb's, and Theodoros Stamos's flowing and revolving imagery into a thoroughly individual sensibility."[40] About Merrill Wagner (born 1935), he writes, "Wagner's ties to the Pacific Northwest are not readily acknowledged in New York, but are evident in her debt to Tobey's mark-making, all-over composition."[41] Regarding Karen Guzak (born 1939), Kangas says, "Guzak studied at Cornish College with Charles Stokes, linking her to Tobey, who taught there in the 1930s."[42] These connections, while true and intended to inform the reader's understanding of the artist and her influences, direct attention away from the value of the artist's own work, pointing instead to her indebtedness to those influences.

Publications do occasionally challenge this norm, but many art critics and historians—men and women alike—continue to frame the work of women within the realm of male influence. The reality of these connections is a measure of how difficult it is to succeed as a woman artist, a reminder of the dominance of men in the arts, and these references hinder women from making their mark on the global narrative of art history in equal measure to men. It is necessary to intentionally fill curricula and collections with contributions of women artists on the basis of their skill and influence, to help emerging women artists see how much has already been done.

Given the continuing lack of women artists in art program curricula, Linda Nochlin's foundational essay, "Why Have There Been No Great Women Artists?," remains relevant 40-plus years since its 1971 publication. Nochlin argued that it was a cultural assumption that women artists' absence from mainstream art history resulted from their inherent abilities, that is, that they were incapable of achieving "greatness."[43] Rather than asking why a woman cannot match male artistic skill, Nochlin instead asked what has prevented women from becoming great. Nochlin admitted that there had not been any agreed-upon great women artists by 1971, but this was not because women lacked ability; rather, the institutions of the art world made it impossible for a woman to achieve a greatness equal to male artists.[44] Art institutions for centuries have, however intentionally or unintentionally, fostered a system of training and reward that favors men over women. While much has changed since 1971, and Nochlin herself acknowledges that today women are some of the best artists in every medium,[45] the influence of institutional structures on the success of women artists and their recognition in art history remains unbalanced.

It is important to note that in the Northwest the balance of men to women in arts administration looks very different from the gender imbalances just described, which is promising for reducing the marginalization of women artists. Women currently run some of the largest arts institutions in the region. Seattle Art Museum, Frye Art Museum, Henry Art Gallery, Western Gallery at Western Washington University, Whatcom Museum, Washington State History Museum, and Tacoma Art Museum all have influential and visionary female directors, and historically, women have run some of the most important commercial galleries and have been some of the most influential donors. In 1950, Zoë Dusanne opened the first commercial gallery in Seattle specializing in Northwest artists, paralleled in Portland by the Fountain Gallery, founded in 1961 by Arlene Schnitzer. Collectors and donors like Schnitzer, Anne Gould Hauberg, Mary Shirley, and Virginia Wright supported the careers of Northwest artists for years. Art advocates and administrators like Anne

Focke—founder of and/or, the Center on Contemporary Art, and Artist Trust, an important source of support for artists in Washington since 1987—have heavily influenced exposure and funding for artists in the region.[46] These dynamics make the Northwest poised to shift the gender imbalance by championing a more diverse group of artists through gallery support, networking, and exhibition and career opportunities.

The accomplishments of women in high-ranking professional positions in the arts in the Northwest are undeniable and unique.[47] Looking beyond the region, one sees that there has never been a female director of the Metropolitan Museum of Art in New York, the Museum of Fine Arts, Boston, or the Art Institute of Chicago, and today male directors head the National Gallery of Art in Washington, DC; the Museum of Modern Art, the Solomon R. Guggenheim Museum, and the Whitney Museum of American Art in New York; and the J. Paul Getty Museum and Los Angeles County Museum of Art. Yet women are making progress nationwide regardless of their absence from these major museums, and the conspicuous dominance of women in the field in the Northwest signals a distinct opportunity to create sustained change. The women in arts administrative roles, in addition to the women at the UW who are reaching the highest academic achievements, can demonstrate to young artists and professionals the opportunities available to them. These women can champion and highlight the work of female artists in order to correct the historical absence of women from mainstream art history, but they must do so with an awareness of their legacy.

The stories of women painters at the University of Washington, one example of an institution working to overcome the systemic roots that privilege men over women, prove the importance of reflection on past practices. Layne Goldsmith sees that many of her female students are increasingly self-possessed and aware of their options, benefiting from the advancements of the women's movement but taking opportunities for granted.[48] Some may argue that this is a postfeminist world. But feminism demands equality for all humans. This is not just a matter of increasing the numbers of women represented in galleries or of including a select few female voices in art history narratives, but rather of advocating for systemic, global change. The fight is far from over. If institutions and artists understand the history of women in the arts and the limitations these artists have faced, if they seek expansive definitions of "great art" beyond the boundaries of history and tradition, and if they correct the institutional structures that have perpetuated gender bias, then the art world could see a broad expansion of artistic expression. It is time to reinvigorate our efforts to convince institutional leaders, professors, curators, gallerists, collectors, critics, and historians to see that increasing diversity involves looking beyond tradition, taking risks, and encouraging innovation both in the arts and in their own practices. Reconsidering Camille Patha's life within this cultural context will lead to a more nuanced appreciation of her career, her work, and her place in the art history of the Pacific Northwest and beyond.

# Notes

1   Conversation with Camille Patha, July 26, 2013.

2   Jo Hockenhull, "Eastern Washington: Pullman and Spokane, 1970–1990," in *Modernism and Beyond: Women Artists of the Pacific Northwest*, ed. Laura Brunsman and Ruth Askey (New York: Midmarch Arts Press, 1993), 159–60.

3   Conversation with Karen Ganz, July 11, 2013.

4   The terms *woman artist* and *woman painter* are used intentionally to draw attention to the tradition of identifying the gender of a painter only when she is female. The term *man artist* is not common. The gender-neutral term *painter* is regularly assumed to mean male, while female painters are generally described with the gender marker.

5   It is a point of pride for Patha that she did not receive any scholarships or tuition assistance, though she remembers that many of her male peers did. She found outside employment in order to pay her tuition. Camille Patha, conversation with Rock Hushka, August 16, 2013.

6   Karen Ganz, Layne Goldsmith, Barbara Earl Thomas, and Jamie Walker all spoke about the importance of champions and backers to the success and advancement of any artist. Conversations with Karen Ganz, July 11, 2013; Layne Goldsmith, July 8, 2013; Barbara Earl Thomas, August 6, 2013; Jamie Walker, August 9, 2013.

7   Ellen Nichols, "Fay Jones," in *Northwest Originals: Washington Women and Their Art*, ed. Ellen Nichols (Portland, OR: MatriMedia Inc., 1990), 13.

8   Email from Karen Ganz, October 1, 2013.

9   Lois Allan, "Northwest Matriarchs of Modernism: Six Oregon Artists," in *Northwest Matriarchs of Modernism: 12 Proto-feminists from Oregon and Washington*, by Lois Allan and Matthew Kangas (Marylhurst, OR: Marylhurst University, 2004), 6.

10   Conversation with Camille Patha, July 26, 2013.

11   Judy Chicago, preface to *Camille Patha: Geography of Desire*, by Matthew Kangas (Salem, OR: Hallie Ford Museum of Art, Willamette University, 2006), 7.

12   For a perspective on this association, see Whitney Chadwick, "Art History and the Woman Artist," in *Women, Art, and Society* (London: Thames and Hudson Ltd., 1990), 33–34.

13   Regarding this classic argument about sexism and the way that women are taught to acquiesce to their subordination, see Marilyn Frye, *The Politics of Reality: Essays in Feminist Theory* (Berkeley, CA: Crossing Press, 1983), 33–34.

14   Conversation with Jamie Walker, August 9, 2013.

15   Email from Jamie Walker, September 2, 2013.

16   Emails from Jamie Walker, August 10 and August 23, 2013.

17   Conversation with Jamie Walker, August 9, 2013. For the University of Washington's affirmative action policy, see "UW Policy Directory," August 17, 2012, www.washington.edu/admin/rules/policies/PO/EO31.html. For the university's strategies to actively diversify faculty members, see "General Search Tips" in the "Faculty Recruitment Toolkit," n.d., www.washington.edu/diversity/faculty-advancement/faculty-recruitment-toolkit/general-search-tips.

18   It is important to note that in 1986, Shirley Scheier, a printmaker, was hired in what was then a combined painting and printmaking program. Printmaking split from painting soon after. Scheier's arrival predates Ganz's in the department, but to give context to Camille Patha specifically, this text focuses on painting professors.

19   Conversation with Jamie Walker, August 9, 2013.

20   Conversation with Layne Goldsmith, July 8, 2013.

21   Conversation with Karen Ganz, July 11, 2013.

22   Conversation with Layne Goldsmith, July 8, 2013.

23   Email from Karen Ganz, June 20, 2013.

24   Conversation with Barbara Earl Thomas, August 6, 2013.

25   Conversation with Karen Ganz, July 11, 2013.

26   Conversation with Jamie Walker, August 9, 2013.

27   East London Fawcett, "Great East London Art Audit," 2013, http://elf-audit.com/the-results.

28   Rebecca Ratcliffe, "The Gender Gap at Universities: Where Are All the Men?," *Datablog* of the *Guardian* (London), January 29, 2013, www.guardian.co.uk/education/datablog/2013/jan/29/how-many-men-and-women-are-studying-at-my-university#data.

29   Guerrilla Girls, "Do Women STILL Have to be Naked to Get Into the Met. Museum?," n.d., www.guerrillagirls.com/posters/nakedthroughtheages.shtml.

30  The galleries analyzed, as of August 2013, are Butters Gallery Ltd., Foster/White Gallery, Froelick Gallery, G. Gibson Gallery, Grover/Thurston Gallery, James Harris Gallery, Lisa Harris Gallery, Linda Hodges Gallery, Greg Kucera Gallery Inc., Elizabeth Leach Gallery, PDX Contemporary Art, Catherine Person Gallery, Pulliam Gallery, Quintana Galleries, Laura Russo Gallery, Seattle ArtREsource, Francine Seders Gallery, Traver Gallery, Winston Wächter Fine Art, and Gordon Woodside/John Braseth Gallery.

31  All museum exhibition history data is sourced from each museum's own website, each accessed on July 31, 2013.

32  Conversation with Rock Hushka, July 31, 2013.

33  Conversation with Layne Goldsmith, July 8, 2013; email from Layne Goldsmith, August 24, 2013.

34  For further reading about the Northwest school, see Sheryl Conkelton and Laura Landau, *Northwest Mythologies: The Interactions of Mark Tobey, Morris Graves, Kenneth Callahan, and Guy Anderson* (Tacoma and Seattle: Tacoma Art Museum in association with University of Washington Press, 2003).

35  Lois Allan, *Contemporary Art in the Northwest* (Roseville East, Australia: Craftsman House in association with G+B Arts International, 1995), 18.

36  See Allan and Kangas, *Northwest Matriarchs of Modernism*; David F. Martin, *An Enduring Legacy: Women Painters of Washington 1930–2005* (Bellingham, WA: Whatcom Museum of History and Art, 2005); and Barbara Matilsky, *Show of Hands: Northwest Women Artists 1880–2010* (Bellingham, WA: Whatcom Museum, 2010). *An Enduring Legacy* examines the long history of the Women Painters of Washington, an artists' group that has supported women in painting since 1930. Their members included Z. Vanessa Helder, who unlike Patha, Ganz, and Adkison, abbreviated her unusual first name, Zama, but did not conceal Vanessa. The accomplishments of the women described in *An Enduring Legacy* are an important piece of the region's art history.

37  For more information about the historical accessibility of craft mediums to women, see Rozsika Parker and Griselda Pollock, "Crafty Women and the Hierarchy of the Arts," in *Old Mistresses: Women, Art and Ideology* (New York: Pantheon Books, 1981), 50–81.

38  "Entering the Culture: Judy Chicago Talking with Lucy Lippard," in *Judy Chicago*, ed. Elizabeth A. Sackler (New York: Watson-Guptill, 2002), 12.

39  Ibid., 11.

40  Matthew Kangas, "Femform: Late Modernist Painting in the Pacific Northwest," in *Modernism and Beyond: Women Artists of the Pacific Northwest*, ed. Laura Brunsman and Ruth Askey (New York: Midmarch Arts Press, 1993), 98.

41  Ibid.

42  Ibid., 99.

43  Linda Nochlin, "Why Have There Been No Great Women Artists?," *ARTnews* 69 (January 1971): 24.

44  Ibid., 25.

45  Barbara A. MacAdam, "Where the Great Women Artists Are Now," *ARTnews*, February 1, 2007, www.artnews.com/2007/02/01/where-the-great-women-artists-are-now.

46  One complicated perspective on why women have achieved success as arts administrators is that these are "secondary" or "housekeeping activities," considered more natural for women than the primary activity of making art." Lucy R. Lippard, "Prefaces to Catalogs of Three Women's Exhibitions," in *The Pink Glass Swan: Selected Essays on Feminist Art* (New York: New Press, 1995), 52.

47  The success of women in the arts is reflected in GeekWire's article "Girl Power: Seattle Ranked 2nd for Women Entrepreneurs," February 25, 2013, www.geekwire.com/2013/girl-power-seattle-ranked-women-entrepreneurs. This information is a surprising contrast to Seattle's having the worst wage gap in the country compared to other metropolitan areas—women make 73 cents for every dollar a man earns. See the National Partnership for Women and Families website for state-by-state details about the wage gap, www.nationalpartnership.org/issues/fairness/wage-gap-map.html. For a broader view of the progress women are making in education and leadership, and the obstacles they face in the health, safety, and economic sectors, see the report by the Women's Funding Alliance, *The Power to Do More: A Path Forward for Women and Girls*, n.d., www.wfalliance.org/docs/The_Power_to_Do_More.pdf.

48  Conversation with Layne Goldsmith, July 8, 2013.

Fifty Years of Painting by Camille Patha

1

**Big Red**, 1964
Oil on canvas
72 × 48 inches
Collection of Swani Joselyn McGrath

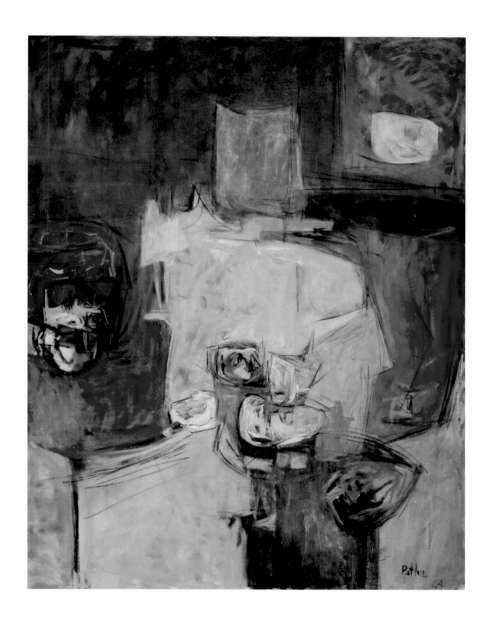

2

**Untitled (soft green)**, 1966
Acrylic on paper
14 × 10⅝ inches
Tacoma Art Museum, Gift of the artist,
2005.37.3

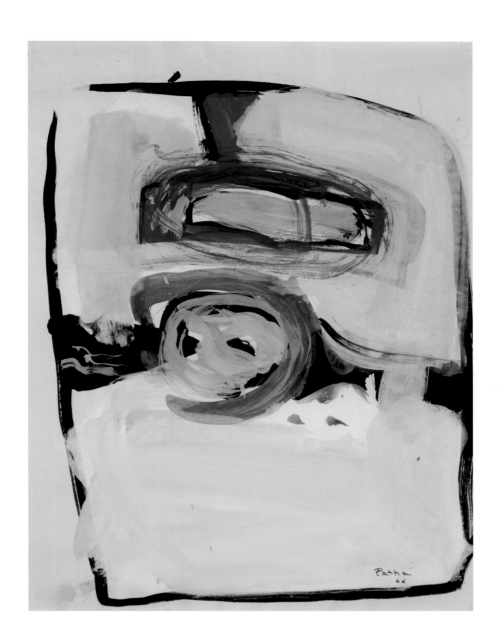

3

**Untitled (strong pink)**, 1966
Acrylic on paper
9¾ × 8¹⁵⁄₁₆ inches

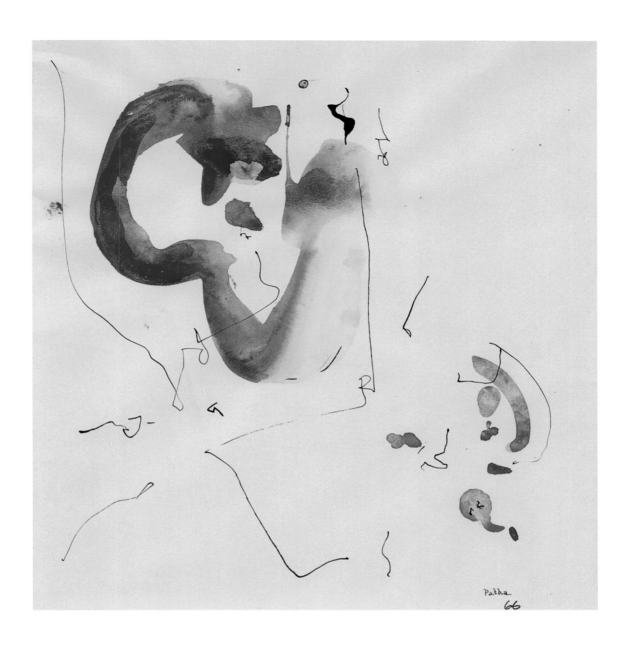

Patha
66

4

**New Purpose**, 1966
Oil on canvas
48 × 46 inches
Museum of Northwest Art,
Gift of the artist, 2006.010

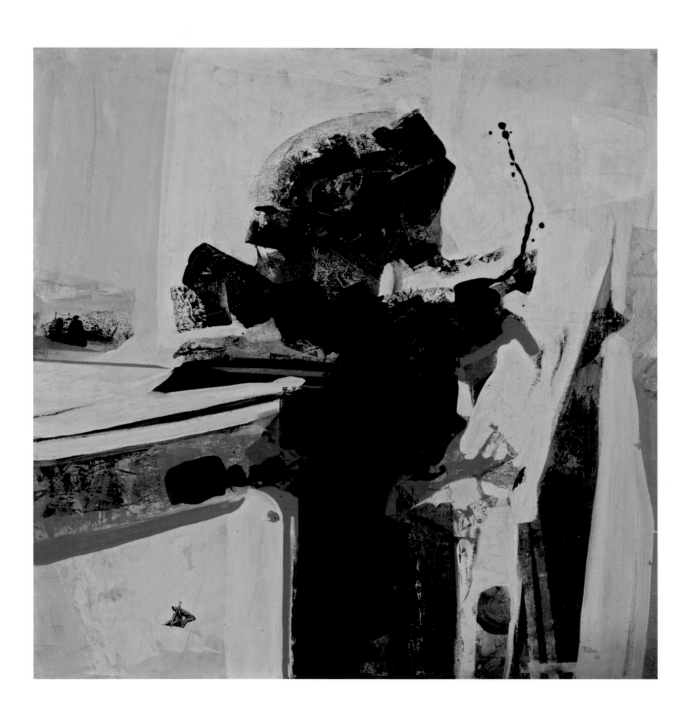

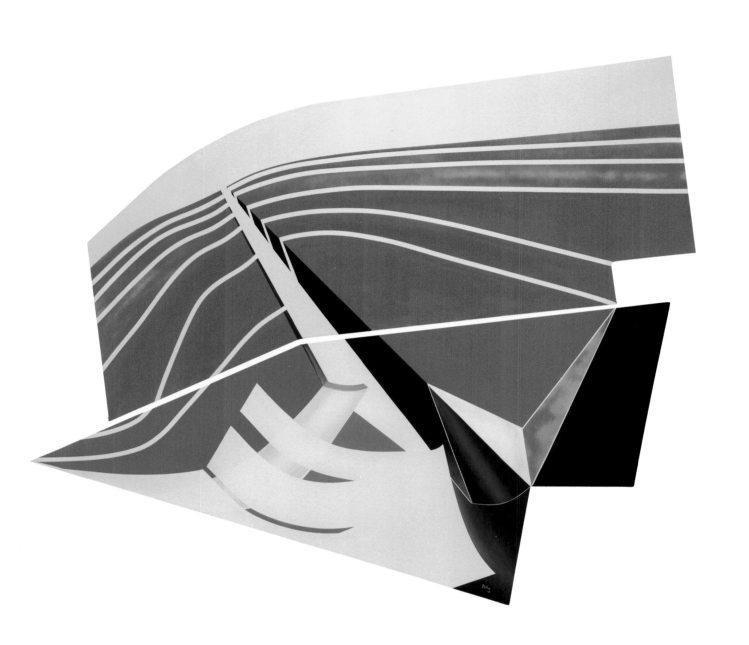

5

**Space Game**, 1968
Acrylic on canvas
Two panels installed: 96 × 101 inches

6

**Boxed Lunch**, 1971
Acrylic on canvas
55⅜ × 81½ inches

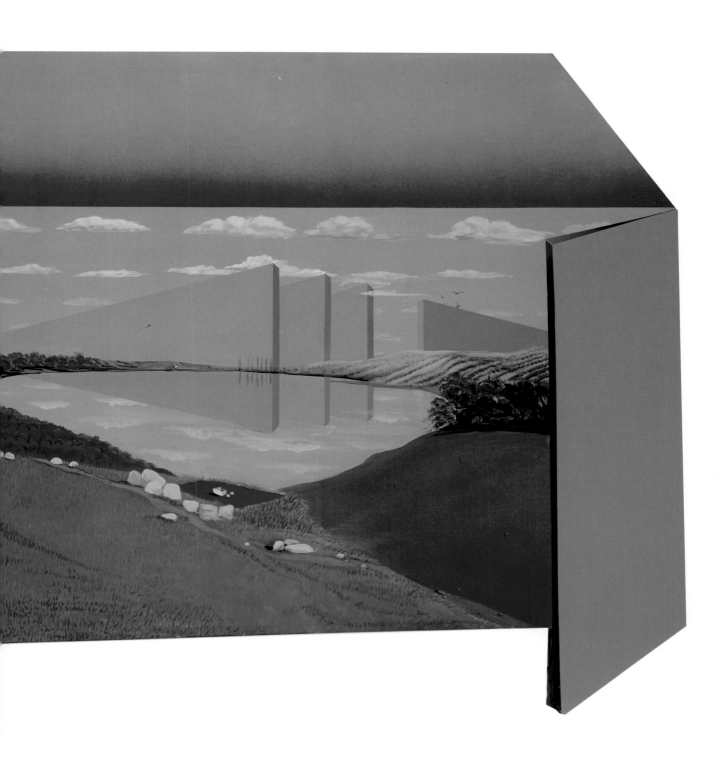

7

**Pie in the Sky**, 1973
Oil on canvas
10 × 10 inches
Collection of Nancy and Arthur Sullivan

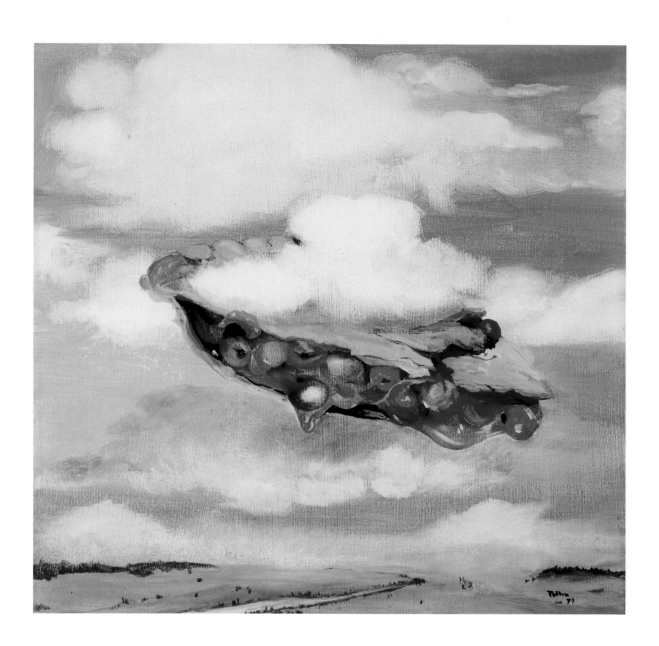

8

**Arches of Air**, 1974
Acrylic on canvas
54 × 64 inches
Collection of Peter and Cyd Dolliver

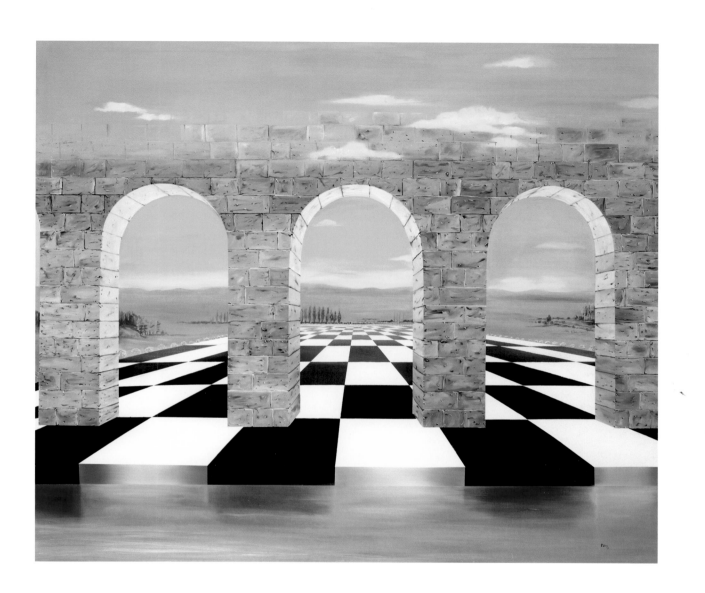

9

**The Conductor**, 1975
Acrylic on Masonite
47¼ × 47¼ inches
Tacoma Art Museum, Gift of the artist, 1976.4

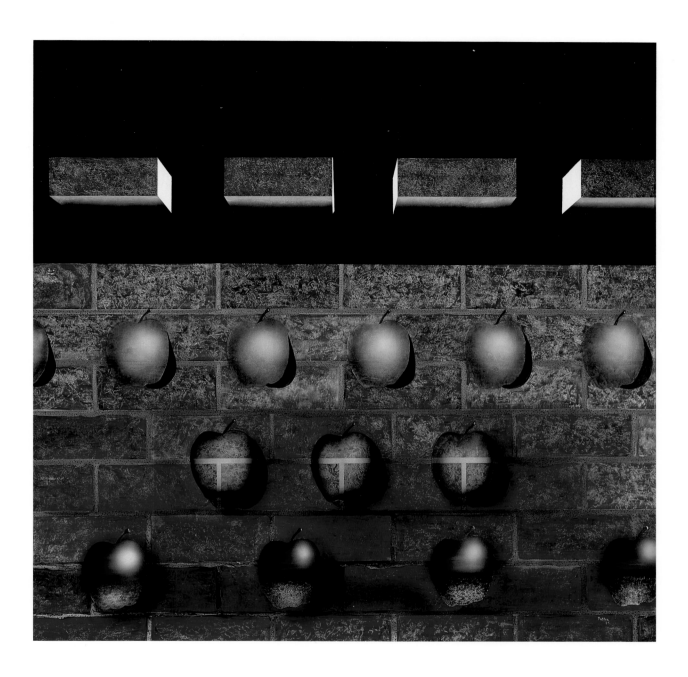

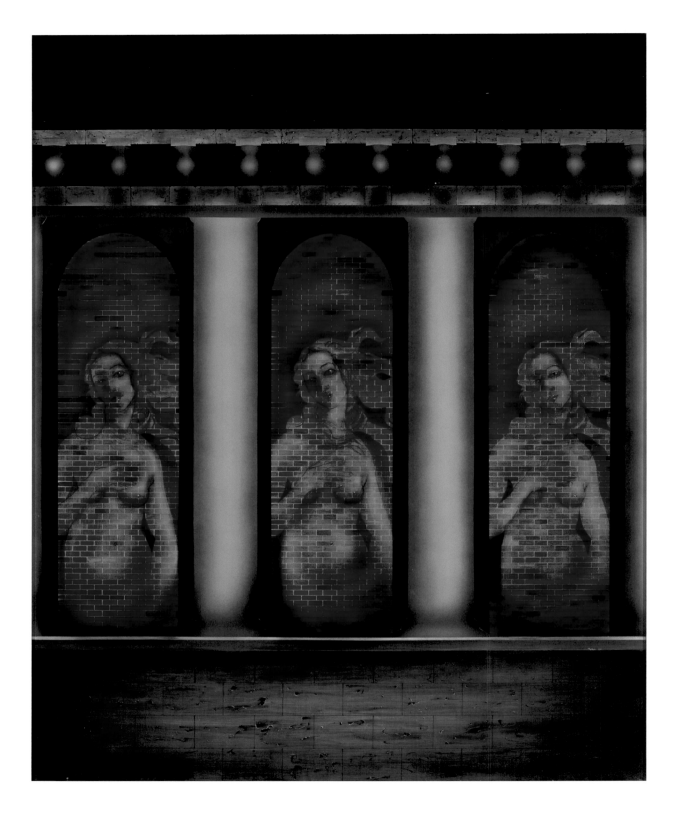

10

**Walled Venus**, 1975
Acrylic on board
72 × 48 inches
Collection of Dr. and Mrs. Frederick Davis

11

**An Honest Self-Portrait After 1974**, 1976
Acrylic on board
20 × 14 inches
Collection of Vincent and Maria Porteous

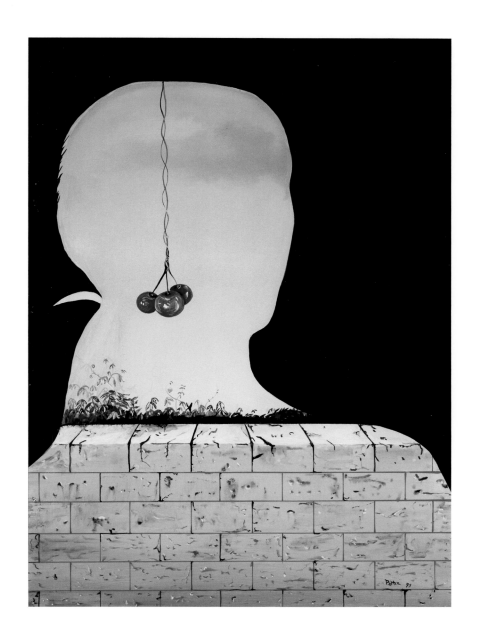

12

**Passages**, 1977
Acrylic on board
54 × 33 inches
Collection of Peter and Cyd Dolliver

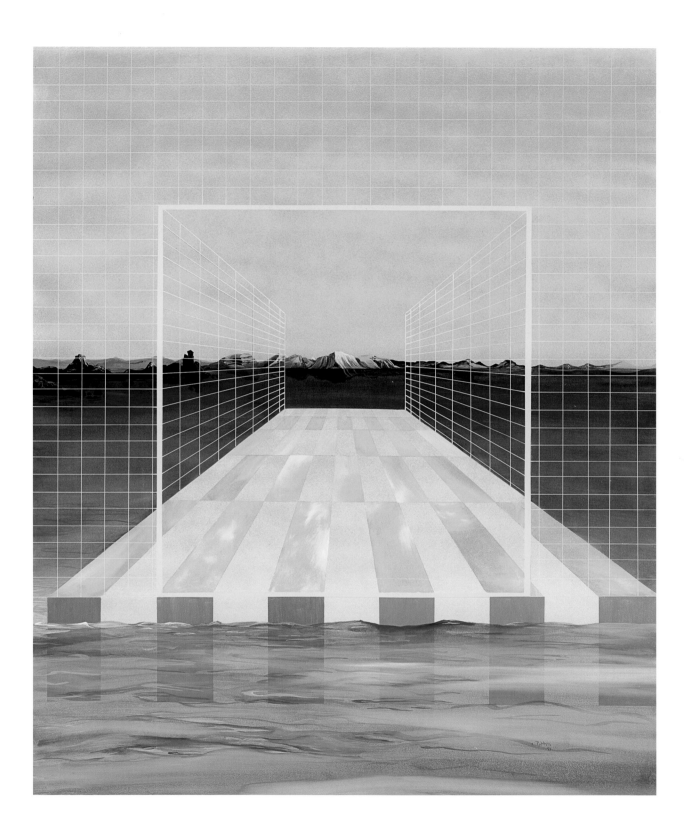

13

**Generalife**, 1977–78
Acrylic on board
44 × 36 inches
Collection of Aylene Bluechel
and David Yonce

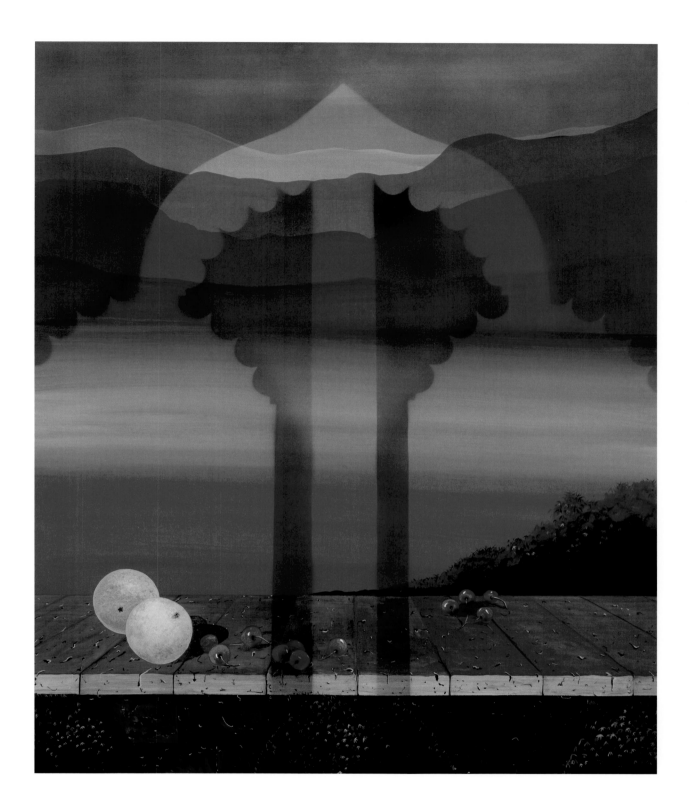

14

**Beach Triptych**, 1978
Acrylic on canvas
Three panels installed: 36 × 60 inches
Collection of Ted and Carmelle Callow

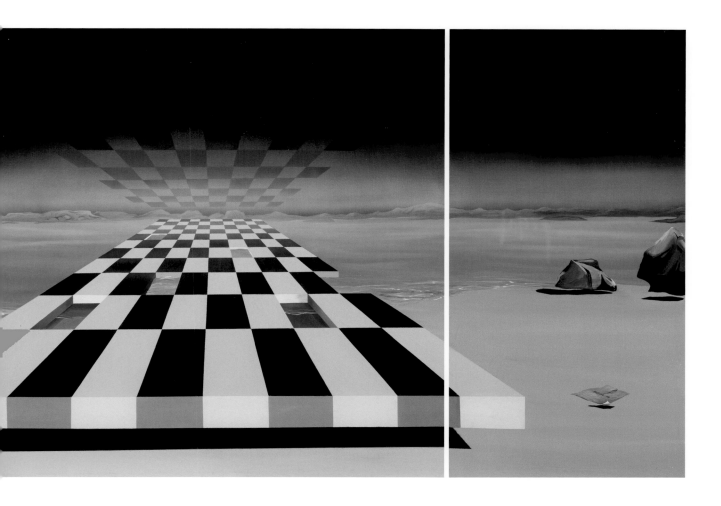

15

**Genesis**, 1980
Acrylic on canvas
48¾ × 42½ inches
Jundt Art Museum, Gonzaga University,
Gift of the artist, 2005.10.2

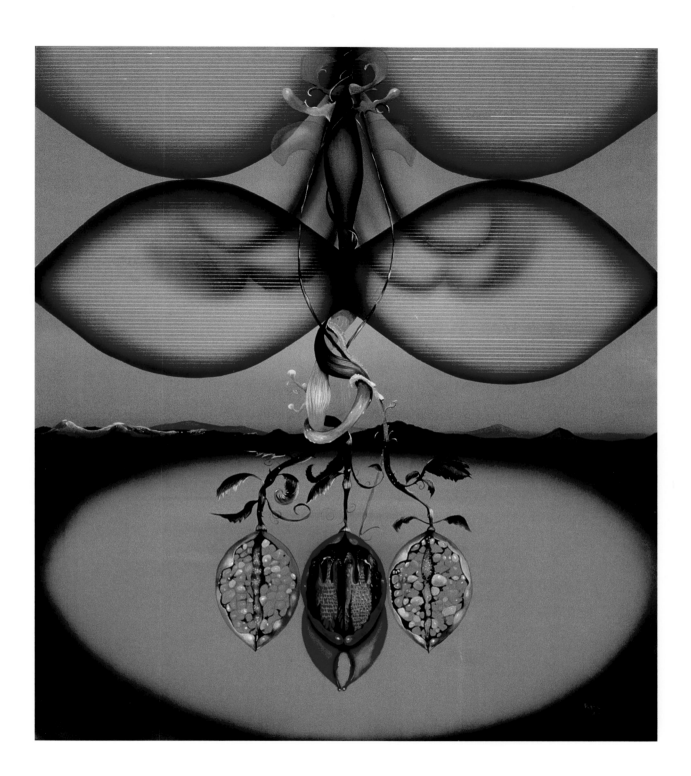

16

**Flamingos I Have Known and Loved**, 1981
Acrylic on canvas
48 × 42 inches
Tacoma Art Museum, Gift of the artist,
2005.37.2

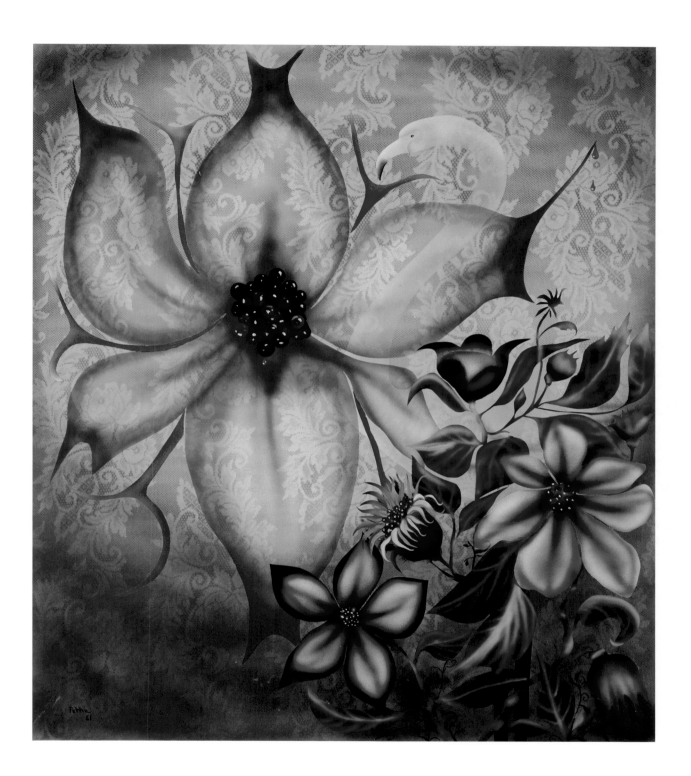

17

**Self-Portrait**, 1983–85
Acrylic on canvas
Three panels installed: 36¾ × 86 inches
Collection of D. A. Jahaske

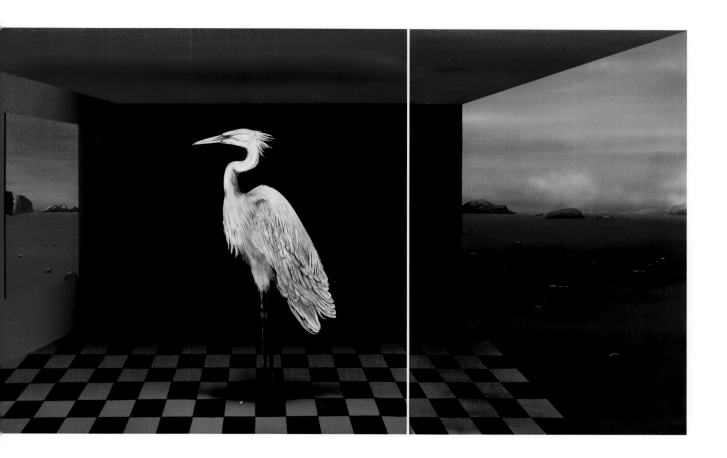

18

**Ancestral Spirit Bird**, 1985
Acrylic on canvas
54 × 72 inches
Collection of Nola and Clyde Sparks

19

**Launching Violet**, 2004
Oil and encaustic on canvas
69½ × 61½ inches
Jundt Art Museum, Gonzaga University,
Gift of the artist, 2005.10.1

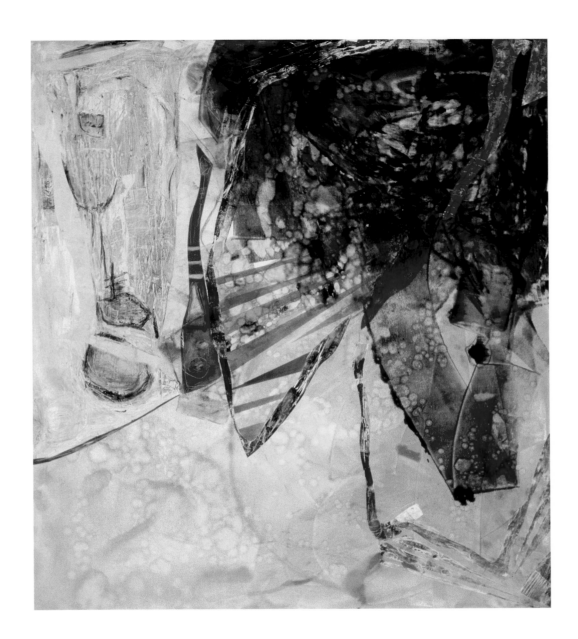

20

**White Arrival**, 2004
Oil and encaustic on canvas
48 × 46 inches
Collection of Janine Coburn

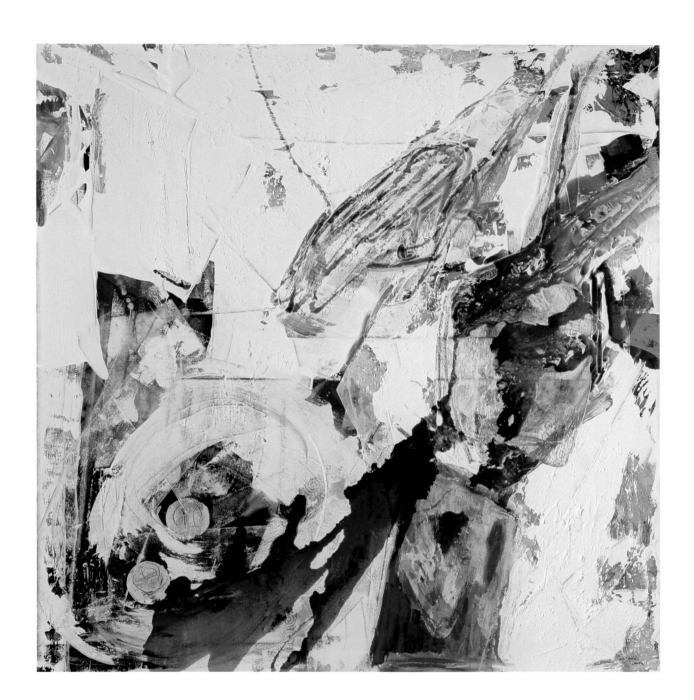

21

**Bordeaux Passage**, 2005
Oil and encaustic on canvas
92 × 81 inches

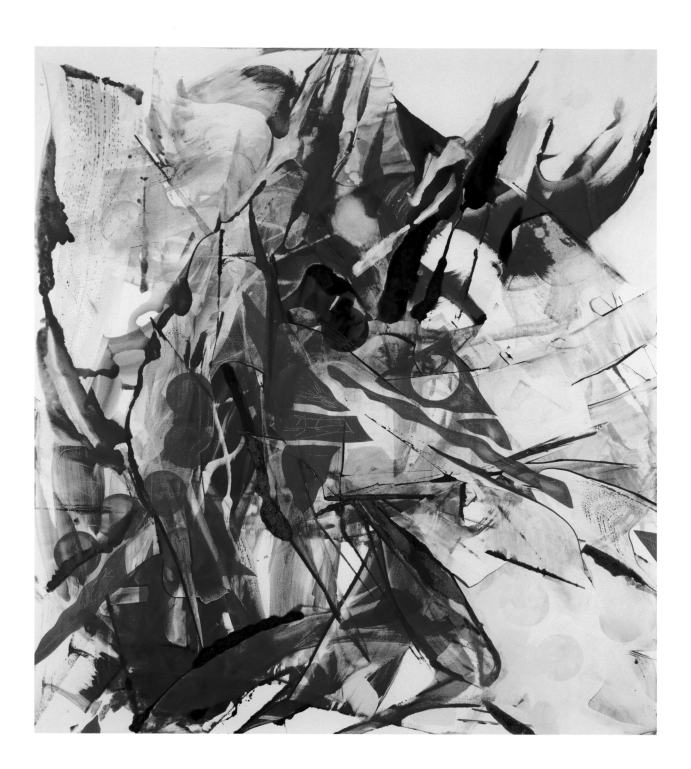

22

**Lucent Thicket**, 2005
Oil and encaustic on canvas
103 × 75 inches
Tacoma Art Museum, Gift of the artist,
2005.37.1

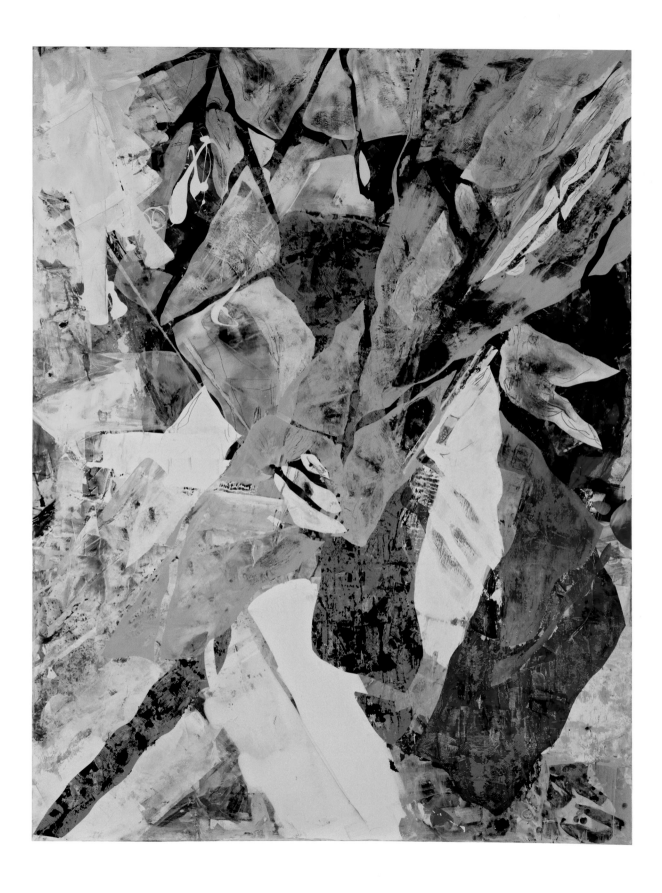

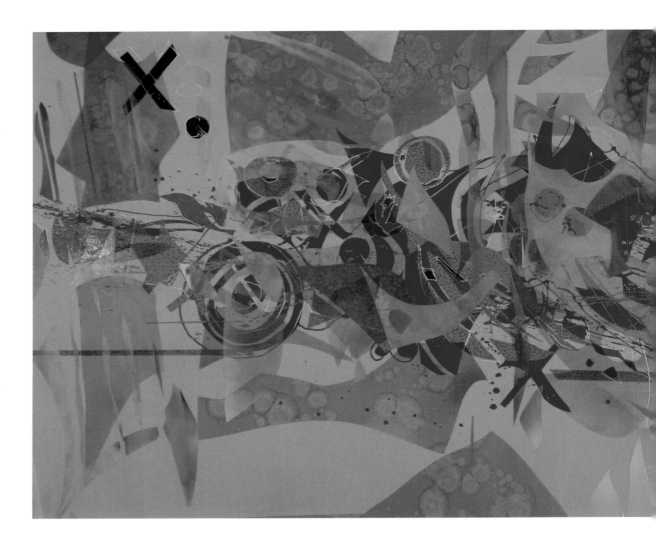

23

**Yella Thrilla**, 2008
Oil on canvas
Two panels installed: 36 × 96 inches
Collection of Dorie and Robert Hordon

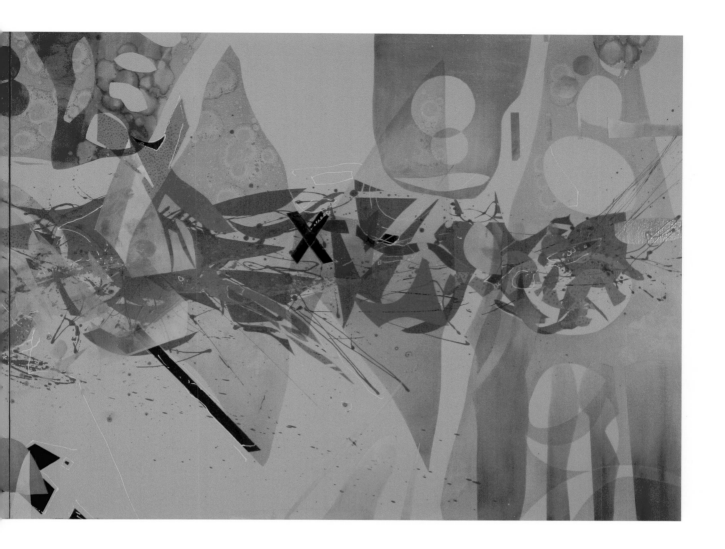

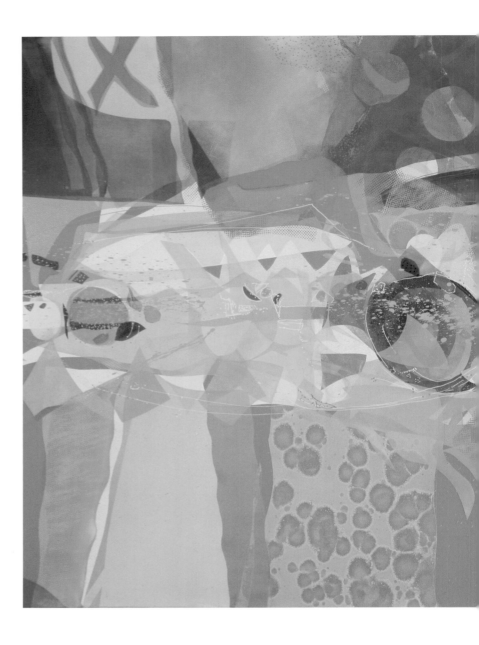

24

**Tropican**, 2009–10
Oil on canvas
48 × 96 inches
Private collection

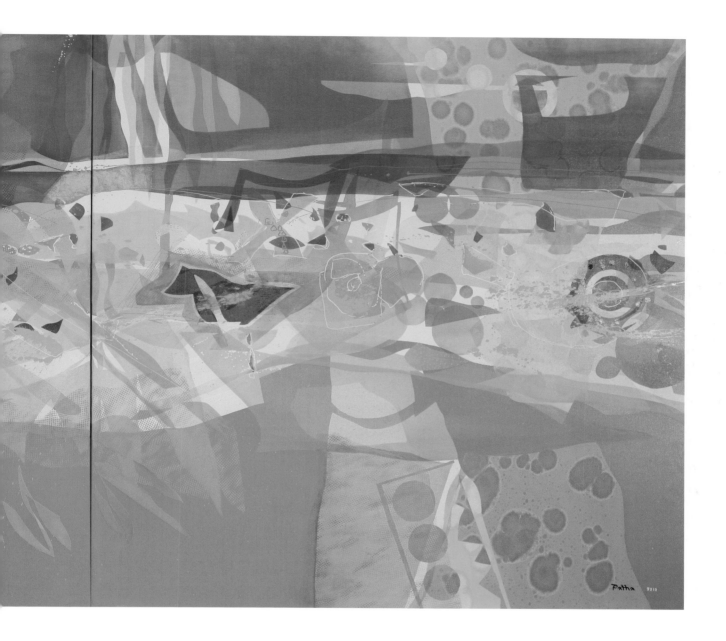

25

**Perpetually Forward**, 2011
Oil on board
24 × 24 inches
Collection of Richard and Laurel Rand

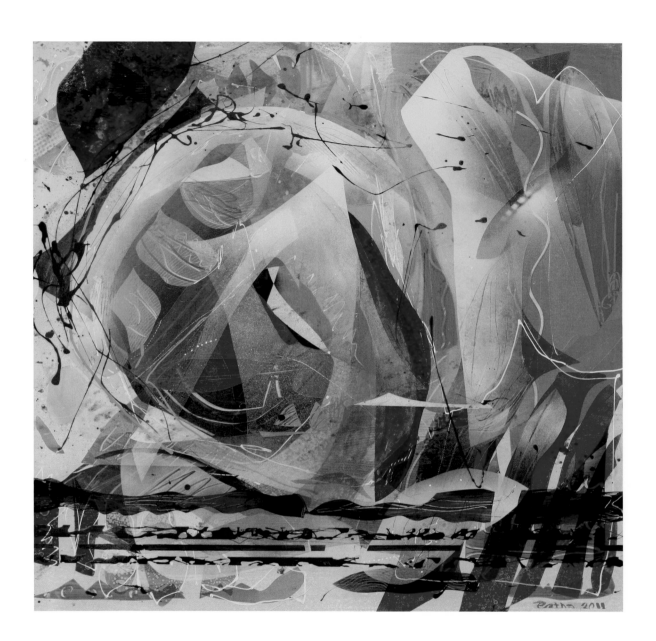

26

**The Juicier the Berry**, 2011
Oil on board
Two panels installed: 24 × 36 inches

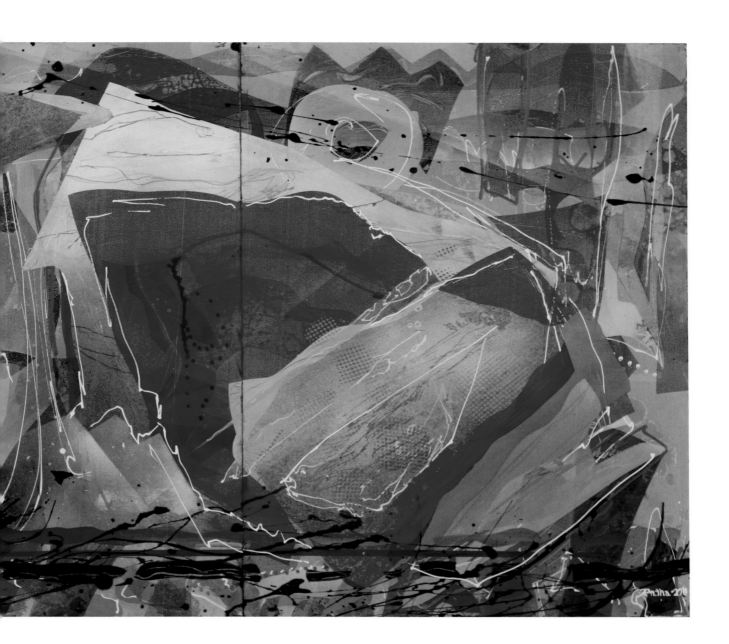

27

**Punch**, 2013
Oil on canvas
60 × 60 inches

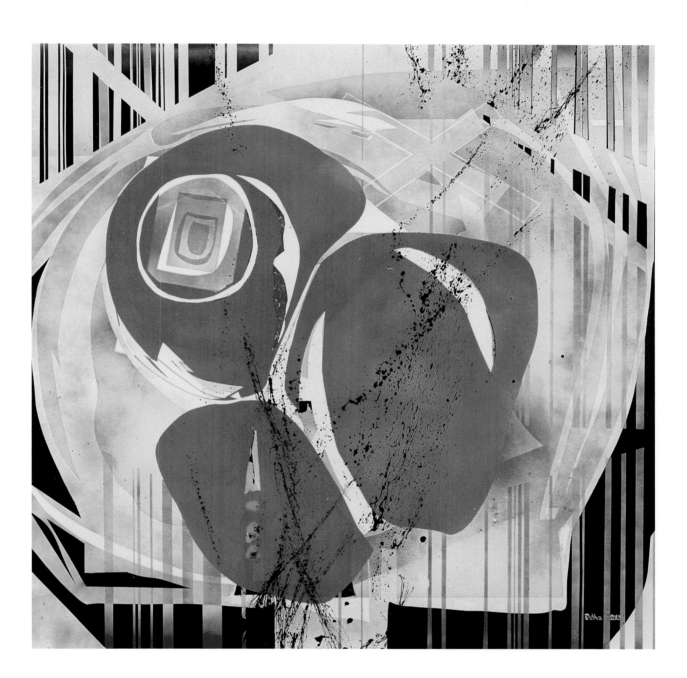

28

**Self-Portrait at Midnight**, 2013
Oil on canvas
60 × 48 inches

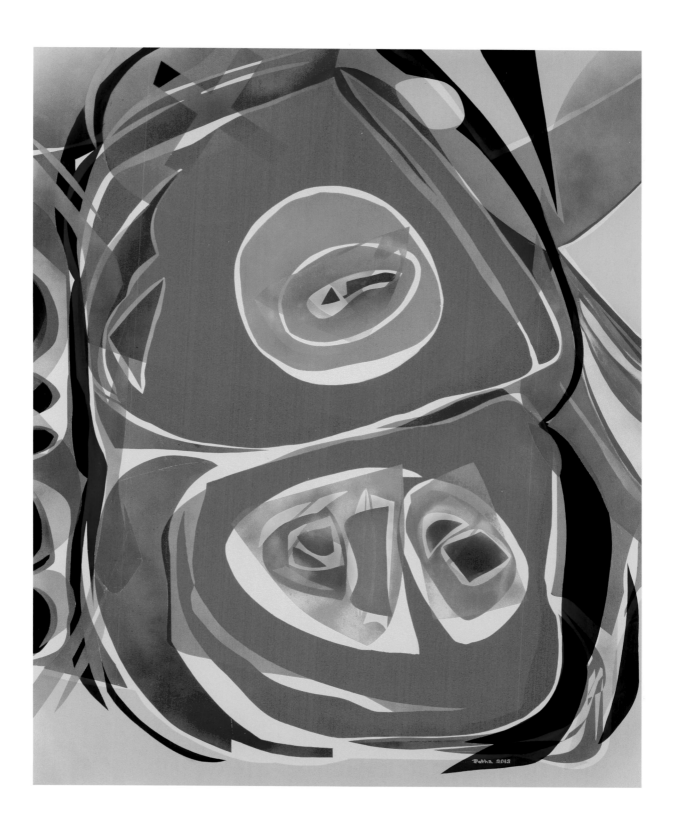

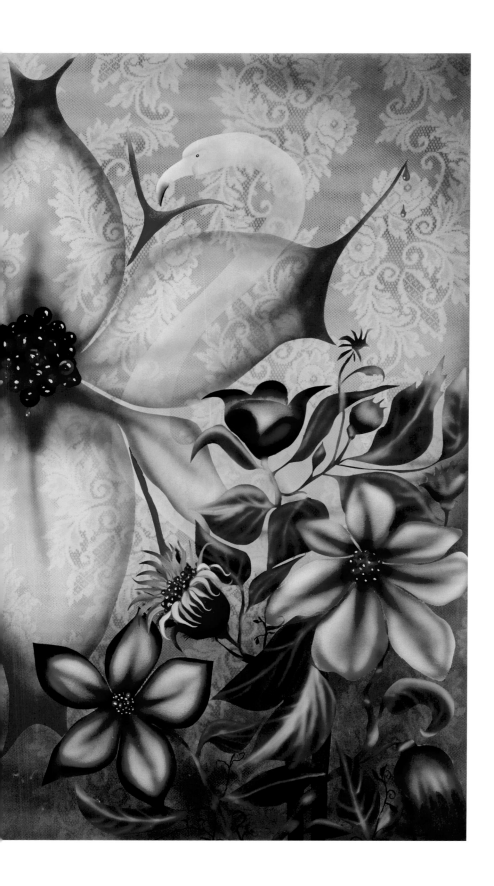

Height precedes width.
All works are in the collection of
the artist unless otherwise noted.

**Big Red**, 1964
Oil on canvas
72 × 48 inches
Collection of Swani Joselyn McGrath

**Untitled (soft green)**, 1966
Acrylic on paper
14 × 10⅝ inches
Tacoma Art Museum, Gift of the artist,
2005.37.3

**Untitled (strong pink)**, 1966
Acrylic on paper
9¾ × 8¹⁵⁄₁₆ inches

**New Purpose**, 1966
Oil on canvas
48 × 46 inches
Museum of Northwest Art,
Gift of the artist, 2006.010

**Space Game**, 1968
Acrylic on canvas
Two panels installed: 96 × 101 inches

**Boxed Lunch**, 1971
Acrylic on canvas
55⅜ × 81½ inches

**Pie in the Sky**, 1973
Oil on canvas
10 × 10 inches
Collection of Nancy and Arthur Sullivan

**Arches of Air**, 1974
Acrylic on canvas
54 × 64 inches
Collection of Peter and Cyd Dolliver

**The Conductor**, 1975
Acrylic on Masonite
47¼ × 47¼ inches
Tacoma Art Museum, Gift of the artist, 1976.4

**Walled Venus**, 1975
Acrylic on board
72 × 48 inches
Collection of Dr. and Mrs. Frederick Davis

**An Honest Self-Portrait After 1974**, 1976
Acrylic on board
20 × 14 inches
Collection of Vincent and Maria Porteous

**Passages**, 1977
Acrylic on board
54 × 33 inches
Collection of Peter and Cyd Dolliver

**Generalife**, 1977–78
Acrylic on board
44 × 36 inches
Collection of Aylene Bluechel and
David Yonce

**Beach Triptych**, 1978
Acrylic on canvas
Three panels installed: 36 × 60 inches
Collection of Ted and Carmelle Callow

**Genesis**, 1980
Acrylic on canvas
48¾ × 42½ inches
Jundt Art Museum, Gonzaga University,
Gift of the artist, 2005.10.2

**Flamingos I Have Known and Loved**, 1981
Acrylic on canvas
48 × 42 inches
Tacoma Art Museum, Gift of the artist,
2005.37.2

**Self-Portrait**, 1983–85
Acrylic on canvas
Three panels installed: 36¾ × 86 inches
Collection of D. A. Jahaske

**Ancestral Spirit Bird**, 1985
Acrylic on canvas
54 × 72 inches
Collection of Nola and Clyde Sparks

**Launching Violet**, 2004
Oil and encaustic on canvas
69½ × 61½ inches
Jundt Art Museum, Gonzaga University,
Gift of the artist, 2005.10.1

**White Arrival**, 2004
Oil and encaustic on canvas
48 × 46 inches
Collection of Janine Coburn

**Bordeaux Passage**, 2005
Oil and encaustic on canvas
92 × 81 inches

**Lucent Thicket**, 2005
Oil and encaustic on canvas
103 × 75 inches
Tacoma Art Museum, Gift of the artist,
2005.37.1

**Yella Thrilla**, 2008
Oil on canvas
Two panels installed: 36 × 96 inches
Collection of Dorie and Robert Hordon

**Tropican**, 2009–10
Oil on canvas
48 × 96 inches
Private collection

**Perpetually Forward**, 2011
Oil on board
24 × 24 inches
Collection of Richard and Laurel Rand

**The Juicier the Berry**, 2011
Oil on board
Two panels installed: 24 × 36 inches

**Punch**, 2013
Oil on canvas
60 × 60 inches

**Self-Portrait at Midnight**, 2013
Oil on canvas
60 × 48 inches

94

Staff

Stephanie A. Stebich, Director

Kara Bonavia, Public Programs and
    Volunteer Coordinator
Ryan Branchini, Museum Educator
Renea Brown, Visitor Services
    Representative
Joan Budd, Development Assistant
Derrek Bull, Security Officer
Margaret Bullock, Curator of
    Collections and Special Exhibitions
Melinda Campbell, Store Manager
Irene Conley, Security Officer
Kelly Crithfield, Assistant to the
    Director and Administrative
    Coordinator
Matthew Daugherty, IT Systems and
    Facilities Manager
Kim Disney, Visitor Services
    Representative
Zoe Donnell, Exhibitions and
    Publications Manager
Thomas Duke, Manager of
    Membership and Annual Giving
Tobin Eckholt, Development
    Services Manager

Cameron Fellows, Deputy Director/
    Director of Administration
    and Finance
Jon French, Security Officer
Laura Fry, Haub Curator of Western
    American Art
Alejandra Garceau, Store Clerk
Kara Hefley, Director of Development
Amy Hollister, Manager of Corporate
    and Foundation Relations
Rock Hushka, Director of Curatorial
    Administration and Curator of
    Contemporary and Northwest Art
Breezy Hutton, Interim Education
    Assistant
Ellen Ito, Exhibition and Collection
    Assistant
Megan Jones, Visitor Services
    Manager
Caitlin Keely, Gala Manager
Kris Knab, Café Staff
Boun Lameny, Facilities and Security
    Lead
Ali Lever, Café Staff
Lucas J. Cole Mattson, Graphic and
    Web Design Coordinator

Alison Maurer, Curatorial Fellow
Jeffrey Melton, Visitor Services Lead
Joshua Proehl, Interim Director of
    Education and Community
    Programs Manager
Linda Rabadi Fair, Associate Director
    of Development
Vitoria Ramos, Store Lead
Zenia Rodriguez, Visitor Services
    Representative
Joseph Rome, Visitor Services
    Representative
Victoria Scalise, Café Staff
Jonathan Smith, Finance Manager
Jon Spencer, Chef and Café Manager
Sara Stewart, Visitor Services
    Representative
Pei Pei Sung, Graphic and Web Design
    Manager
Lisa Terry, Communications and
    Public Relations Manager
Melissa Traver, Director of Marketing
    and Communications
Jessica Wilks, Registrar
Kristie Worthey, Associate Director
    of Museum Services

Published in conjunction with the exhibition
*A Punch of Color: Fifty Years of Painting by
Camille Patha* which appears at Tacoma Art
Museum from February 8 through May 25, 2014.
It takes part in the *Northwest Perspective Series*
of one-person exhibitions devoted to artists of
the region.

This exhibition is generously funded by
Jon Shirley, The Greater Tacoma Community
Foundation, and Tacoma Arts Commission.
Seasonal support provided by ArtsFund.

This catalogue is made possible by support
from Janine Coburn, Susan Russell Hall and
Dale Hall, Paul and Alice Kaltinick, and Molly
and Joe Regimbal.

Tacoma Art Museum
1701 Pacific Avenue
Tacoma, WA 98402

Distributed by
University of Washington Press
P.O. Box 50096
Seattle, WA 98145-5096
www.washington.edu/uwpress

Library of Congress Cataloging-in-Publication Data
A punch of color : fifty years of painting by
Camille Patha / Rock Hushka, Alison Maurer.
     pages cm
  Includes bibliographical references.
  ISBN 978-0-924335-40-2 (hardback)
  1. Patha, Camille, 1938– —Exhibitions.
I. Hushka, Rock, 1966– author. Power and paint.
II. Maurer, Alison, author. Contextualizing
Camille. III. Patha, Camille, 1938– Paintings.
Selections. IV. Tacoma Art Museum.
ND237.P25415A4 2014
759.13—dc23                     2013045374

Produced by Marquand Books, Inc., Seattle
www.marquand.com

Designed by John Hubbard
Edited by Julie Van Pelt
Project managed by Zoe Donnell
Proofread by Alison Maurer and Carrie Wicks
Typeset in Tablet Gothic by Marie Weiler
Image management by iocolor, Seattle
Printed and bound in China by Artron Color
Printing Co., Ltd.

**COPYRIGHT PERMISSIONS**

**PHOTOGRAPHIC CREDITS**